Carving Noah's Ark

NOAH & FRIENDS

With the Animals of Africa

David Sabol

Step-by-step
Instructions
Plus
24
Original
Patterns

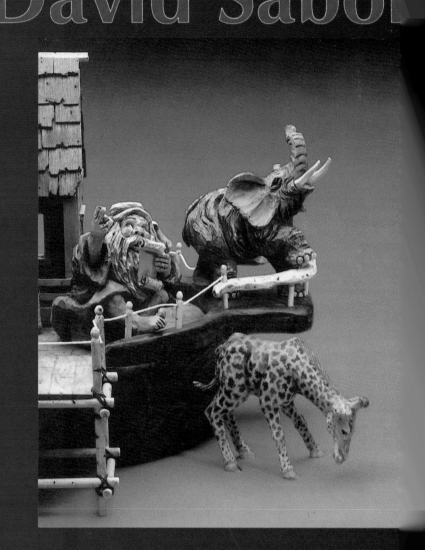

Schiffer Publishing Ltd

77 Lower Valley Road, Atglen, PA 19310

Text written with and photography by Jeffrey B. Snyder

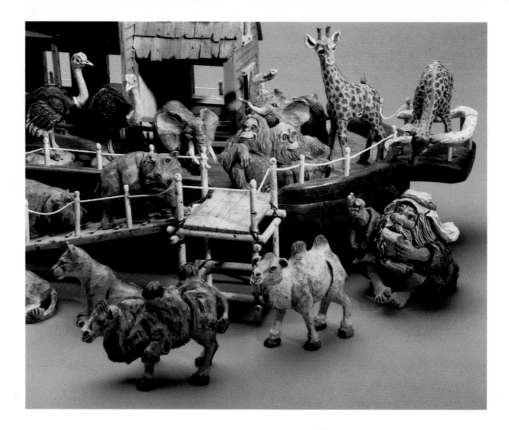

Contents

Copyright © 1995 by David Sabol

Library of Congress Cataloging-in-Publication Data

Sabol, David.
 Carving Noah's Ark : Noah & friends, with the animals of Africa /
David Sabol ; text written with and photography by Jeffrey B.
Snyder
 p. cm. -- (A Schiffer book for woodcarvers)
 ISBN 0-88740-779-X (soft)
 1. Wood-carving. 2. Wood-carved figurines. 3 Noah's ark in art.
4. Animals in art. I. Snyder, Jeffrey B. II. Title. III. Title :
Noah & friends. IV. Series.
TT199.7.S2123 1995
731'.884--dc20
 95-5449
 CIP

Printed in China
ISBN: 0-88740-779-X

Published by Schiffer Publishing Ltd.
77 Lower Valley Road
Atglen, PA 19310
Please write for a free catalog.
This book may be purchased from the publisher.
Please include $2.95 postage.
Try your bookstore first.

We are interested in hearing from authors
with book ideas on related topics.

Introduction

To help you bring the story of Noah's Ark to life, we will go through each step necessary together to begin populating an ark. We will carve Noah, an elephant and a giraffe out of blocks of white pine and paint them with oil stains.

Each step will be clearly shown in photographs and described with straight-forward, confidence-building directions. To add diversity to your animal kingdom, animal pairs each come with patterns for two different poses. The African animals are also animated to accentuate their distinct individual personalities and characteristics. When we are done, you will have created works of intricate detail, realistic finish, and lively character.

My tools of choice for these projects are: a band saw (for cutting out each figure's basic shape from a pine block), a bench knife (I use a Warren #B11 that has been reshaped. The knife blade has been beveled to a point for fine detail.), gouges (numbers 7, 8, 9, 11, and 15), a #7 fishtail gouge, V tools (numbers 12 and 15), veiners (a small veiner and a #12), and a wood burner. Power tool assistance is never used after the initial blank is cut from the pine block. Oil stains are created from oil paints mixed with Minwax, mixed on freezer paper, and applied with brushes (a Langnickel fan brush and numbers 1, 4 and 8). I use Grumbacker #8 as my main brush along with Grumbacker #4 and Langnickel #1. The colorful stains finish each piece and help give them a vibrant, individual character.

I hope you enjoy these projects as much as I do.

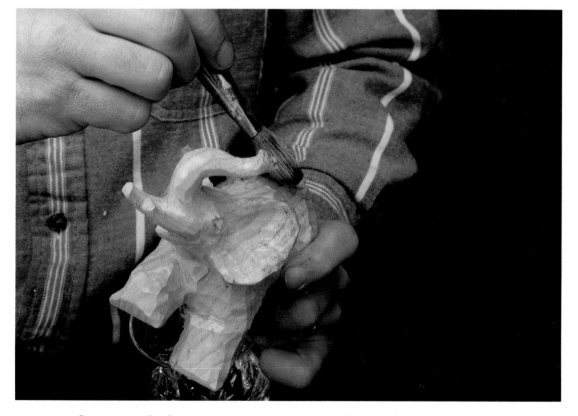

One tip to make these projects proceed more smoothly before we start: whenever the white pine starts to dry out, wet the wood with a broad brush dipped in water. Your bench knife, gouges, and veiners will go through the wood much more smoothly this way. Use this method once and you will never carve dry wood again. Pay particular attention to wetting the end grains as the wood will soak up the water quickly there, making your job that much easier.

Carving Noah

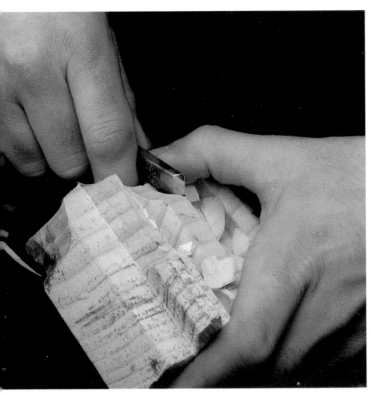

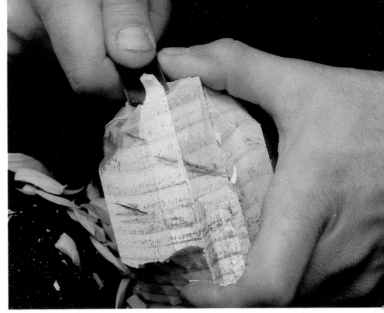

Begin rounding down the left side of the head, starting to expose and shape the angle of the head.

When you cut out the pattern from a 4 3/4" high x 4 1/2" wide block of white pine, make the blank a little bigger than the pattern to give yourself a little leeway. This applies to all of these projects. Once you have cut out Noah's rough pattern from white pine with a band saw, retrace the front and side view patterns onto your blank with a very soft pencil. With the patterns are in place, first remove the excess wood from around his right hand with a #7 gouge. This will expose the area of his face as well. Move on to the left hand once you have finished with the right. I prefer to carve toward myself, using my wrist as a pivot.

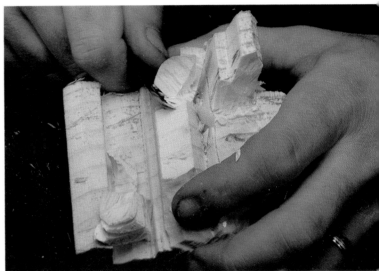

Cut away extra wood beneath the right arm, closing in on the true position of the left hand.

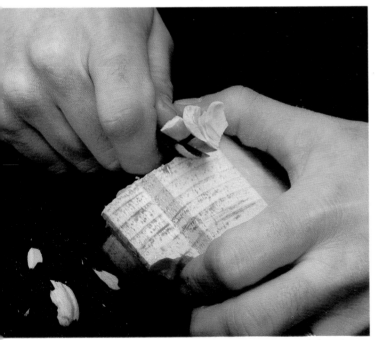

Remove some of the excess wood from around Noah's head to further expose the right hand which is positioned off to the side.

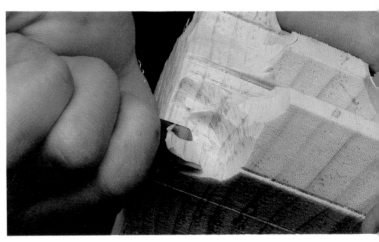

Noah's legs are almost crossed. Begin to establish the angle of the right leg, which is the forward leg. Continuing with the #7 gouge, cut in toward the center of the blank, angling the cut from the outside edge of the blank inward.

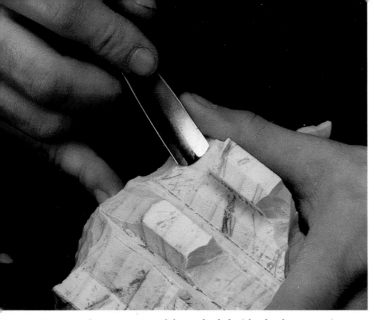

Remove the excess wood from the left side, further exposing the forward extended right foot. Be careful to leave enough wood for the left leg and foot which are tucked back tight to Noah's body and the hay bail he is sitting on.

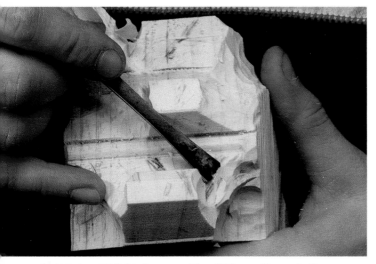

Switch to a #7 fishtail gouge. It's a little smaller and allows better access and control in tight places. First we'll use it to establish the location of the left leg. Both feet are almost on the same center line with the left foot behind the right.

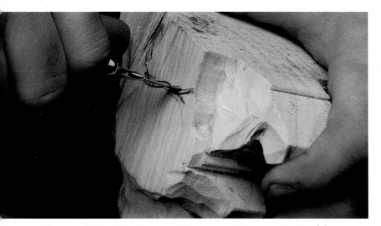

Now we'll find the hay bail Noah is sitting on. As Noah's coat is hanging over the hay bail, we want no straight cuts. First make two stop cuts straight in about 1/4 of an inch with a bench knife along the penciled pattern lines.

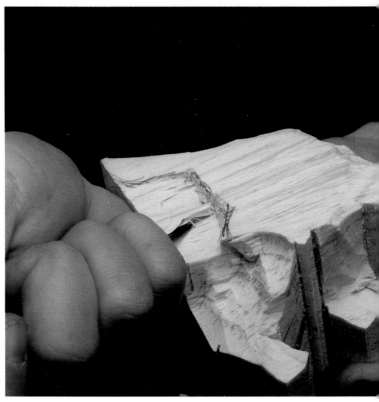

Use the #7 fishtail gouge to cut the hay bail down to size, following the stop cuts.

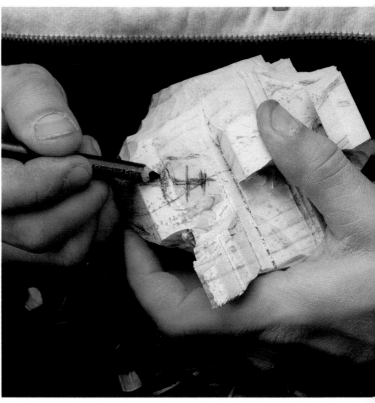

Let's find Noah's face. When carving an angled head you establish the center line from the forehead to the chin on the angle you wish the head to be. The lines for the eyes, nose and mouth all have to be 90 degrees to the center line and parallel to each other. This is fundamental. To begin the process, make a line where Noah's headpiece begins along your angled centerline. Add the lines of the other facial features next.

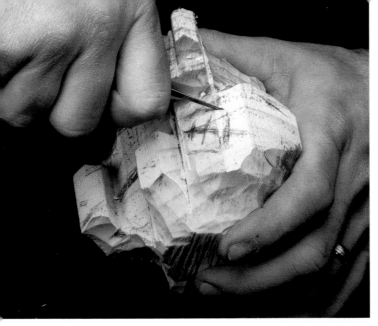

With our lines in place, we can begin giving Noah a face. All of this will be done with a bench knife, a #7 fishtail gouge, and a small #11 gouge. Make a stop cut on the forehead and along the sides of the face with the bench knife.

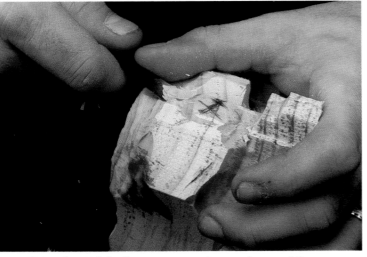

Using the #7 fishtail gouge, recess the wood around the nose. The nose is the highest point.

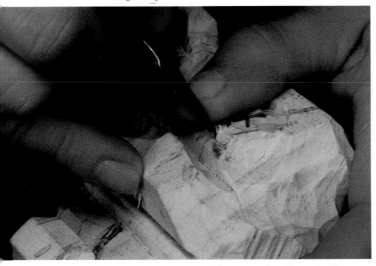

The bottom of the nose meets Noah's mustache. Draw in the mustache now. Make a deep stop cut along the line of the mustache which will give us our cheek area.

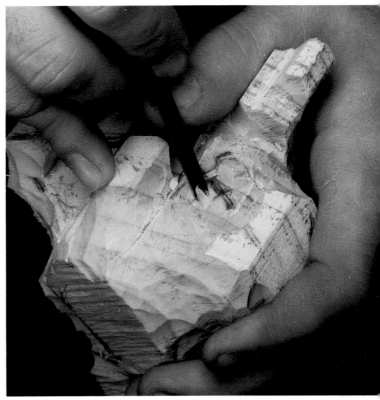

Take the #11 gouge and establish the thickness of the nose by making two cuts the same distance apart from the centerline. Don't cut too close to the center line, you have to leave yourself a little room for the nostrils.

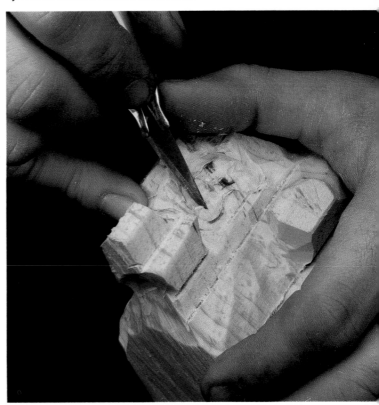

Round off the cheeks with the bench knife, working down to the stop cut line along Noah's mustache. This creates our mustache line. Remember to keep the area of the nose wide for now.

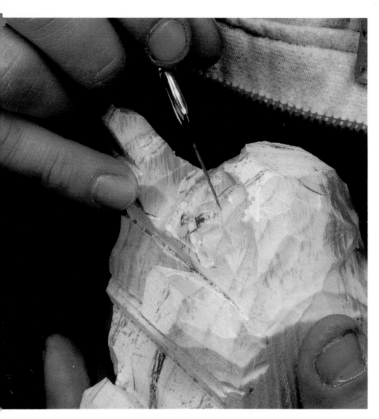

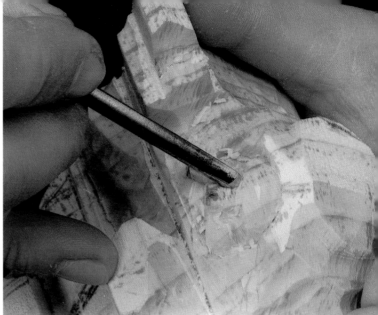

The forehead is not straight across. It has two rounded areas where the eyes will be. Using the #11 gouge, make two sweeping semi-circular cuts beginning at the outside of the eye and moving in toward the nose. This is a little face so these are small cuts.

The point of the nose is the highest on the face, everything else is recessed. Carve away around the nose to expose the facial features. Carve back the bridge of the nose to the forehead.Recess the forehead a little as well. Remember, the head is on an angle and you must pay close attention to maintain your proportions on both sides. It will help to look at the head straight on, angling the body to do this. It will help you carve symmetrically. Take your time. Smaller cuts are better than bigger ones at this point.

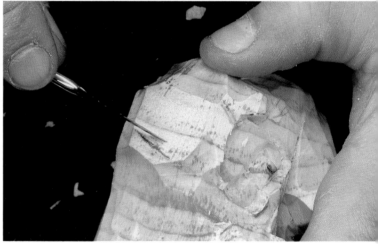

It is time to angle the top of the headpiece angle in the same direction as the rest of the head. My bench knife is resting on the high point and my thumb is on the low point. The back of the headpiece is also sloped more than the front.

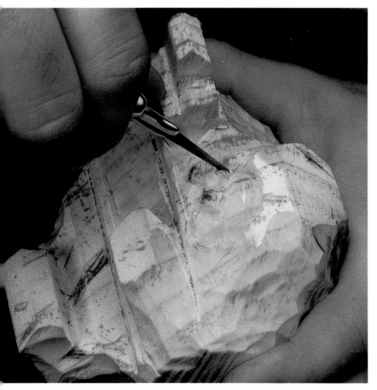

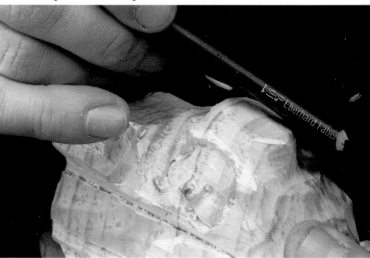

Bring back Noah's nice round cheeks into the sides of the headpiece with the bench knife.

Here is the angled headpiece.

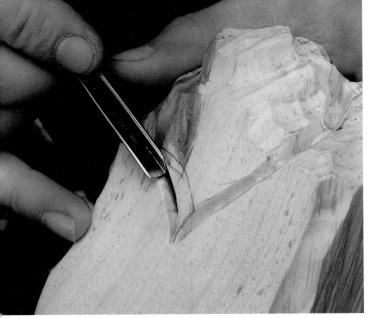

To carve the back of the flowing headpiece, first draw in it's outline. Once drawn, take the V tool and make a series of deep, curving cuts along the pencil lines. Don't be afraid to cut deeply, this accentuates the details of the headpiece.

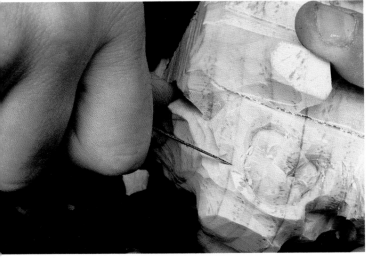

Now cut back the front edge of the headpiece with the bench knife. This will also give us the edge of the beard.

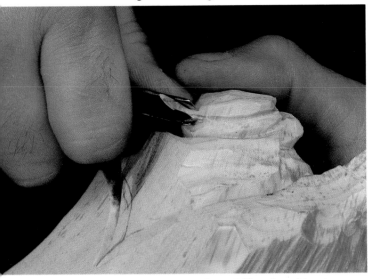

Draw the headband. Cut it in with a #15 V tool, making two circular cuts to establish where the headband will be.

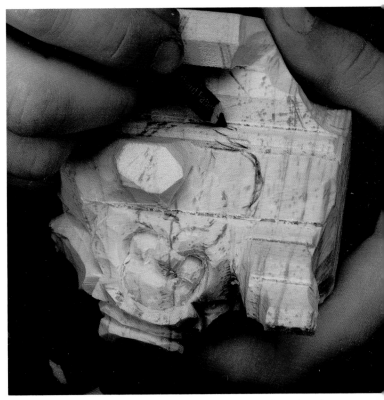

Let's start to establish the beard now. Draw in the beard and mustache first. The mustache curves down, the beard is full.

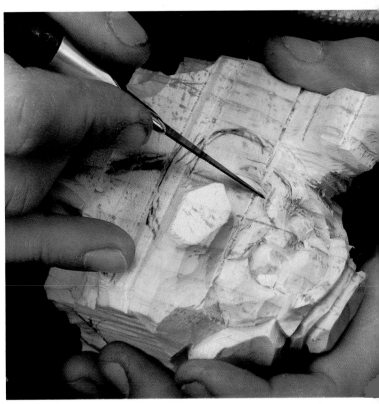

Take the bench knife and cut in the outline of the mustache. Be careful not to cut too deep, you have to leave a little wood for the lower lip.

9

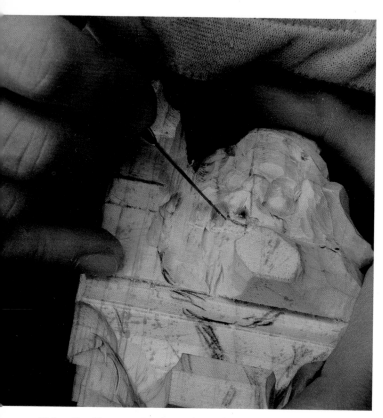

Using the #9 gouge, begin to shape the beard, pulling it back as you go. Always give curves to the cuts to create character and make Noah's beard flow. Old gnarled trees are always the most interesting in the forest. Make this beard interesting too. While we're at it, let's put in the small open mouth as well. This takes four cuts with the bench knife. Two cuts angle straight out and down along the line of the mustache to create the outer edges of the mouth. Make a little rounded cut with the blade tip for the top of the lower lip. A small chip will then pop right out for the mouth.

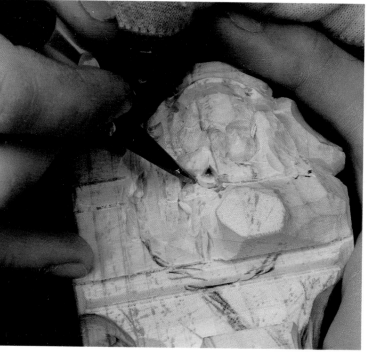

To establish the lower lip, make a stop cut along the pencil line of the lower lip. Then cut at a slight angle back in toward the stop cut line.

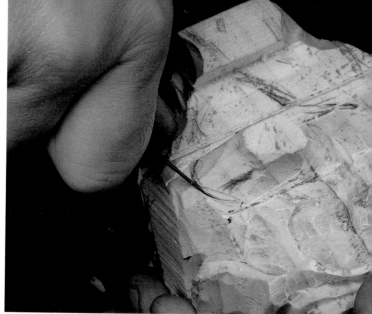

It is time to establish the direction of Noah's left arm, beginning at the point where it angles back into his sleeve. Make a stop cut along the pencil line of the edge of the sleeve.

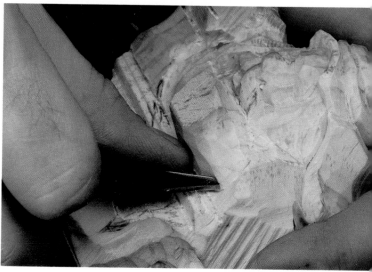

Shape the arm down to fit in the sleeve.

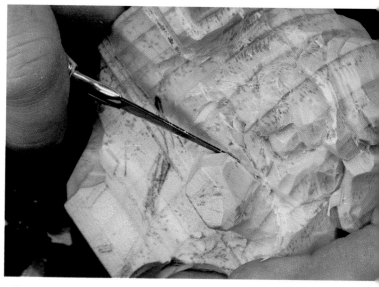

Cut out behind the hand, creating a gap between Noah's left hand and his beard.

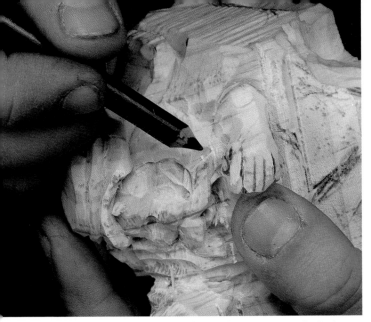

To find the thumb and fingers, first we're going to make little pencil marks where they should be.

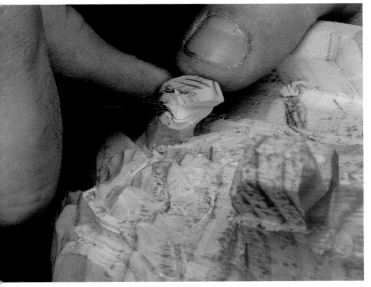

Then we make a tiny cut with the bench knife to separate the thumb from the fingers, creating a little slot with the bench knife. This will hold Noah's scrolling check-list of animals.

Use the bench knife to put in small wavy V cuts along the finger lines to simulate the joints. Congratulations, you've just finished the most difficult hand. The easier right hand we'll save for later.

We're going to get Noah's bare feet going. To do this we establish the size of feet, size of the legs, and positioning of the feet. First make some pencil marks to show the length and the width of the feet. The big toe is going to stick up on the right foot. Pencil this toe in as well. Keep in mind the foot is on an angle, the little toe curled down toward the ground and the big toe up in the air.

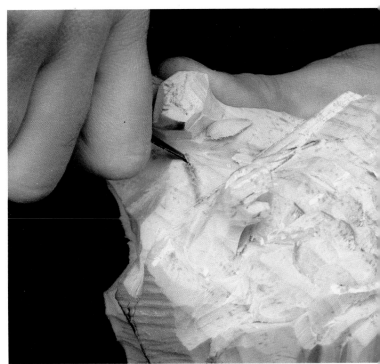

Next, we will recess the back leg, establish where the left foot is, and determine the space between the two legs. For that we'll use the bench knife and the #15 V tool. Draw in your pencil lines first and then cut along the left leg line to define the left leg.

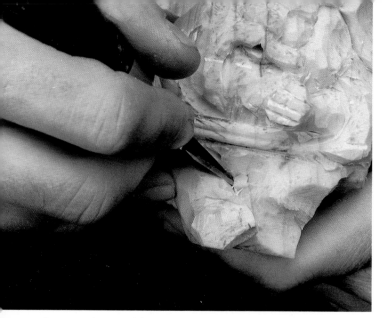

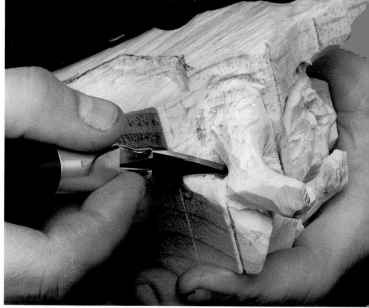

Remove the wood from between the two legs.

Cut under and behind the right leg to separate it from the wood block.

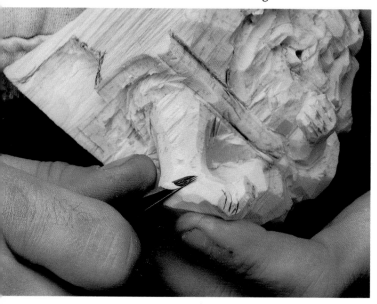

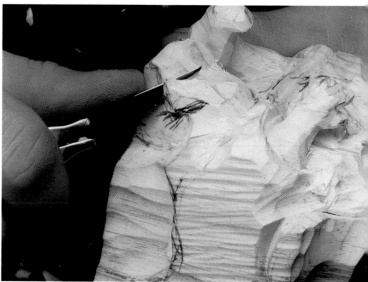

Round and shape the right foot with the bench knife. Remember the foot's shape and don't forget the arch.

As the left foot is angled back, touching the hay bale, we'll cut back the left leg from the knee. Angle your cuts back, following the line of the shin, to the top of the foot with the bench knife.

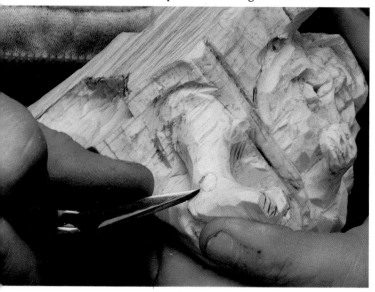

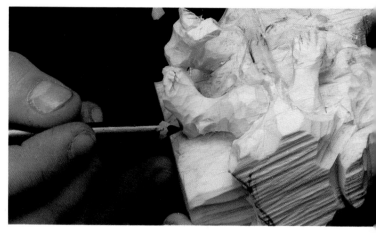

Keep this small circled area mounded up for the ankle bone.

The leg is angled back. Begin shaping the left foot. Try to make sure that both feet are approximately the same size and are in a natural stance. Pencil in the toes.

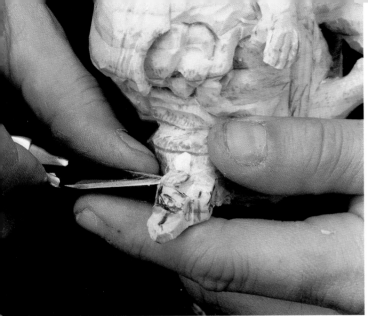

Moving back up to the right arm, pencil in the upraised fingers. Draw in the two folded fingers, thumb and the location of Noah's sleeve. Begin to carve the thumb, folded down and the two raised fingers raised — Noah indicating "Only Two" to the animals. Your own hand will be the best model for carving Noah's.

Take the bench knife and make an angled cut all the way around the arm up to the stop cut. This will create the opening of the sleeve.

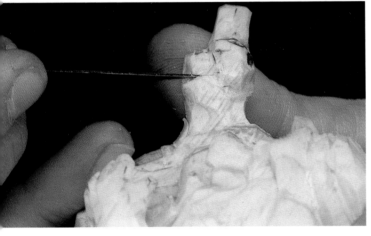

Use the knife blade to create the heavy pad of the palm and the curled fingers like this. Make sure the upraised fingers are no longer than those on the other hand so that neither will appear out of proportion.

Now draw in the sleeve. With the #15 V tool, establish the arm by following the pencil lines and cutting deep.

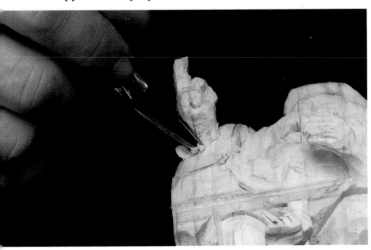

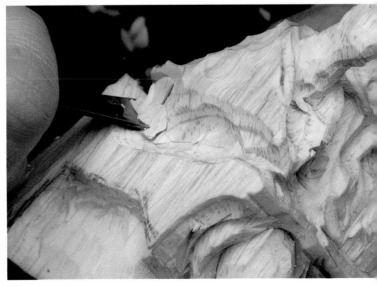

To carve the sleeve, first make a stop cut parallel to the direction of the arm all the way around the arm.

Use the fishtail gouge to round the sleeve.

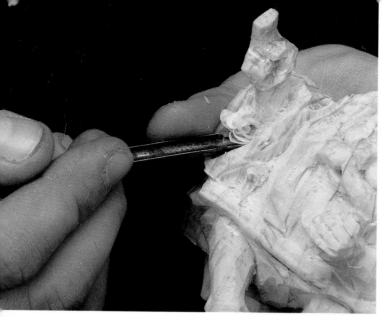

With a #9 gouge, hollow out the sleeve to give it the look of a robe.

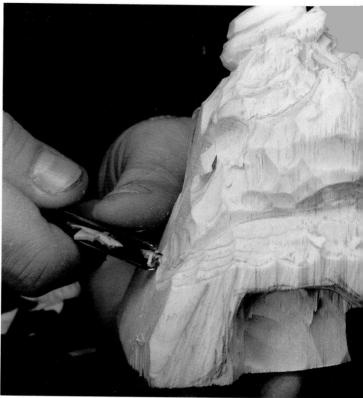

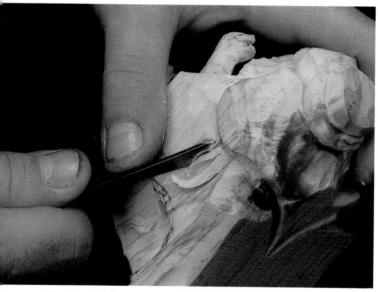

Use the #7 fishtail to recess the wood and create the back of the left arm.

To work on Noah's flowing robe, use the fishtail gouge to reduce the wood around that robe. Use the #15 V tool to create a semi-circular cut indicating where Noah is seated.

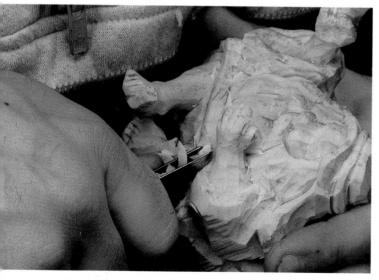

Continue along the lower half of the arm, separating it from the wood block down to the end of the sleeve.

Now we'll round the back of the robe off with the #9 gouge.

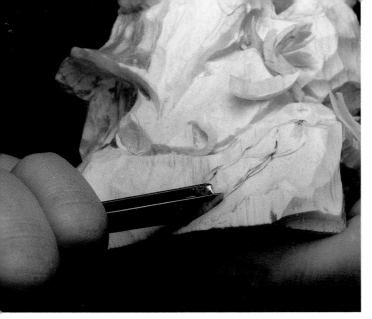

Using the #15 V tool, add some folds to give the robe a little flow and motion. The folds should follow the curves of the body.

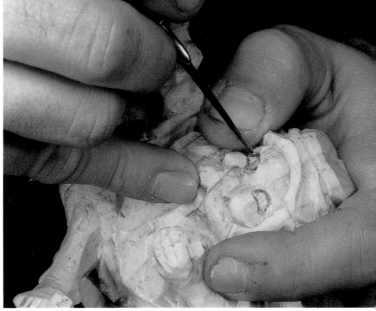

We're ready for the eyes. First draw in the eyes with a sharp pencil. Then take the bench knife and, just using the tip, cut straight in and follow the lines. It is important for the knife to be sharp for this.

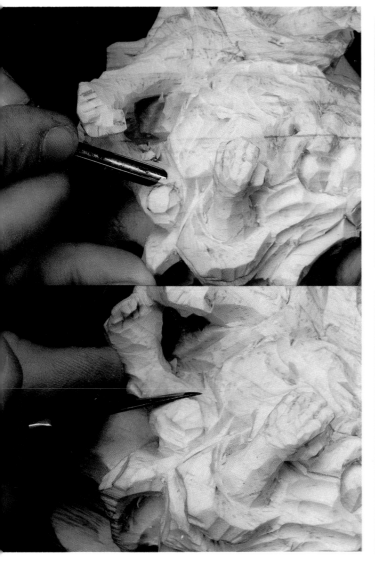

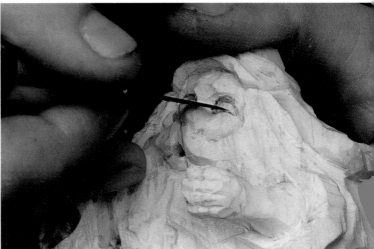

Now round the eyeball within the lids.

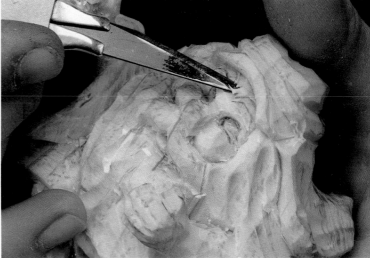

To give Noah little knobby knees, use a #9 gouge in a circular motion to create a groove. Then blend the leg back in with a bench knife.

Pencil in the eyebrows. Follow the outlines with the tip of the bench knife, cutting straight in again to create little quarter moon cuts. Recess the forehead slightly around the eyebrows.

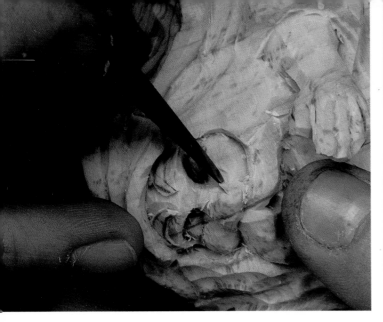

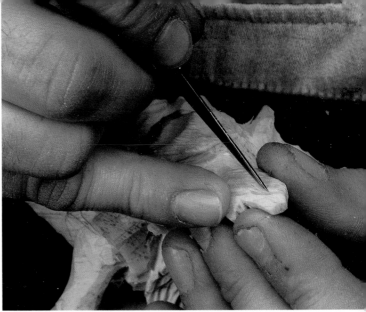

To carve the outside edges of the nostrils, make one little cut parallel to the nostril. Then cut in from the outside of the nose. This creates the outside of the rims of the nostrils.

For some detail, split the two raised fingers just enough to create some definition by making little V cuts with your bench knife. Once again, make the cuts wavy to simulate the joints in the fingers. Repeat the process for the toes.

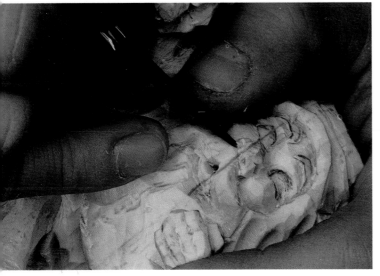

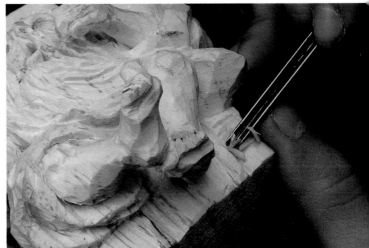

Cut out little holes for the nostrils.

To texture the beard and mustache, use the #12 V tool and make random cuts with curves (alternating long and short cuts) to simulate the hair of a long and flowing beard. Allow some of the lines to intersect. This creates both a slightly unkempt look and a flow form to the beard as well. Start at the side of the lower left hand and work up to the raised right hand to create a good sweeping motion up to that raised hand.

Simulate the hay and straps in the hay bale with a small V tool, making horizontal cuts for the hay and four vertical cuts for the bale straps. The straw should be randomly cut.

Use a wood burner to do a little cleaning up. Burn in under-cuts around the eyes, nose, fingers, toes, and legs. The wood burner will help clean up the cuts and give the carving a clean look. It also gives nice shadows when you are staining.

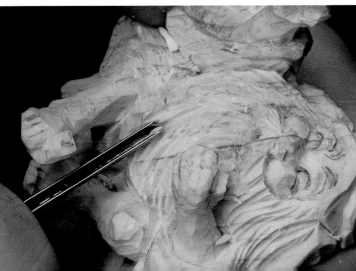

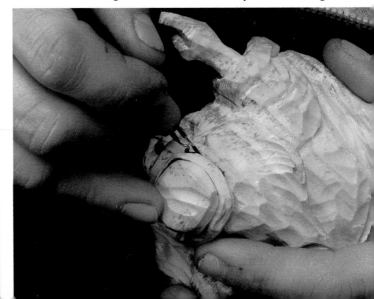

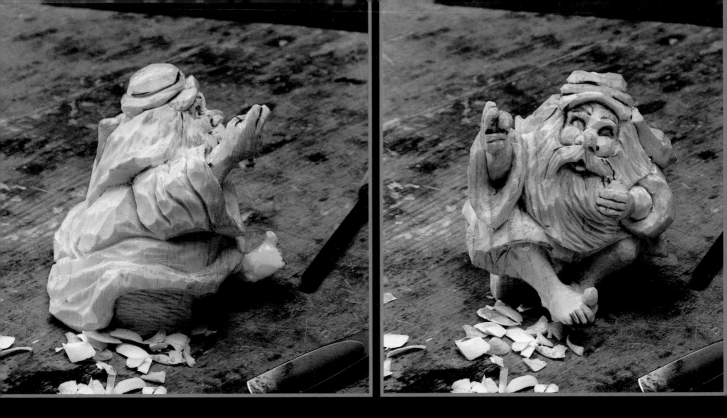

Here is Noah, carved and wood-burned waiting for paint.

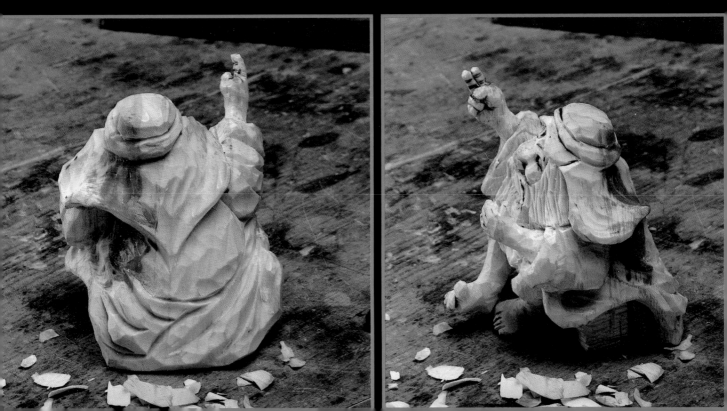

Painting Noah

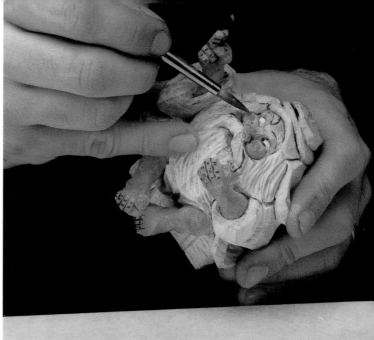

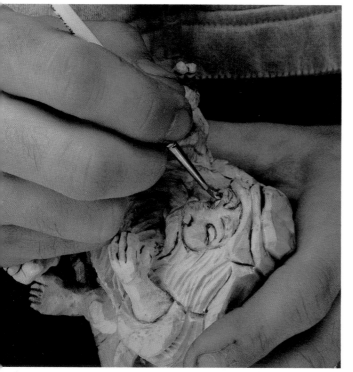

Put a very small amount of cadmium red deep on the knees and toes and blend it in with the Minwax using the same brush to blend it into the flesh tones. Make sure it is a very small amount. Red is a very strong color and you don't need much. Apply to the cheeks and the forearms and the palms and fingers of the hands as well. Dab in very small amounts. A little on the lower lip as well, very faint there.

To paint Noah we're using flesh, raw sienna deep, raw ocher, cadmium yellow, light green, dark green, ultramarine blue, black, white, and a little cadmium red. These are mixed and thinned with Minwax natural to create staining washes unless otherwise stated. We're staining directly on to the raw wood. These is no sealer. I like to use plain freezer wrap with the shinny side up as a palate. We're going to paint the eyes first with the #1 brush so that they'll dry when we come back to put in the pupils. Dab a little white on the whole eyeball.

Next mix up some flesh tone with a little brown ocher and a little ultramarine blue to create a nice flesh tone. Paint the face, hands and feet all at once with this mix.

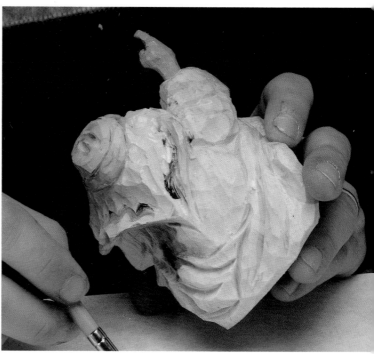

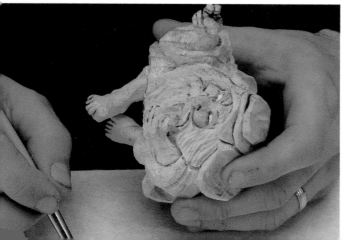

The headpiece is stained with white mixed with a small amount of raw umber. This provides a marvelous old looking fabric, the raw umber toning down the white nicely. Paint the entire headpiece except the band. When painting clothes, sometimes the sloppier the better. Big paint strokes create a sense of motion. Mixing on the carving sometimes works wonders. Don't be afraid to add small amounts of other colors like blue to create highlights and shadows. Add a few highlights of straight white as well.

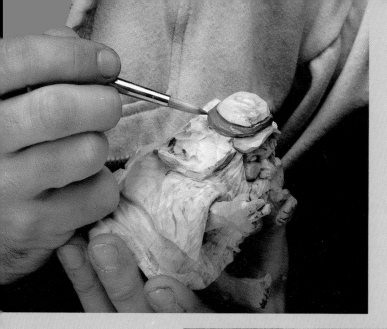

The band may be any color. I like a little brown ocher. It could be red, it doesn't matter. Be bold! I'll highlight the band with little strokes of yellow, dashing them in here and there.

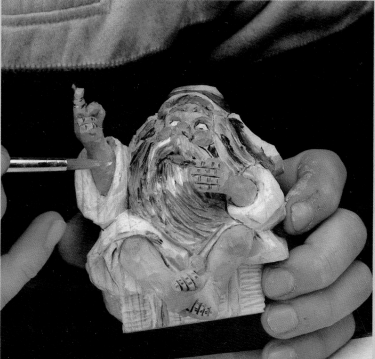

The beard is white mixed with a little black and a touch of ultramarine blue. This creates a gray beard with a little life to it. A tiny amount of burnt umber helps as well. Paint the beard, mustache and eyebrows with these.

I'm using brown ocher for the eyes iris', raised and looking toward his upraised right hand. The iris' are not round circles. They go under the eyelid. You rarely see a persons full eye.

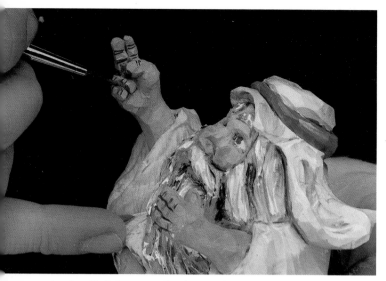

Apply a little brown ocher between the fingers and toes for definition.

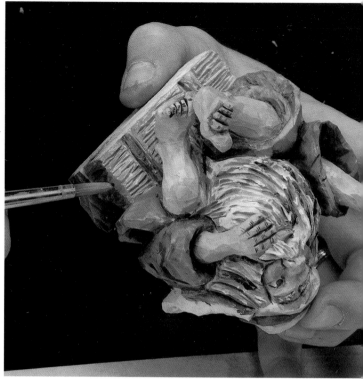

For the hay bale use a little white, yellow and raw sienna. Mix them and apply. Add little yellow highlights as well. The straps are brown ocher and white with a little black.

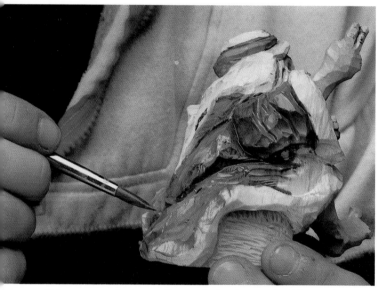

Take some cadmium yellow, mix in ultramarine blue and a little black to get a nice green for the robe. Apply some yellow highlights, a little black and ultramarine blue in the creases and watch the robe come alive.

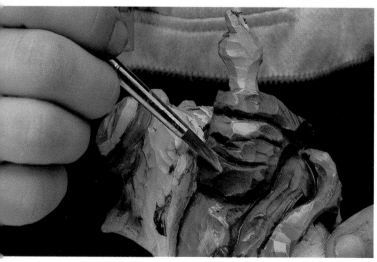

Blend in a little green pale extra as well for highlight.

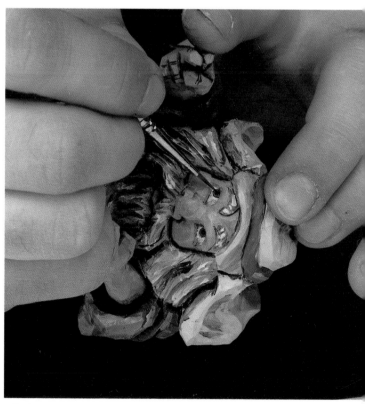

Dab a little black onto the tip of the #1 brush and carefully paint in the pupils.

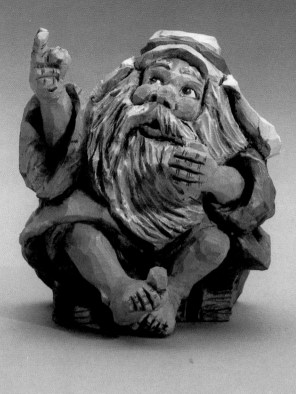

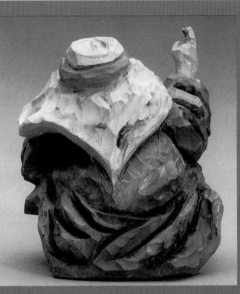

Noah carved, painted, and ready to go.

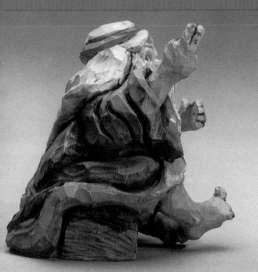

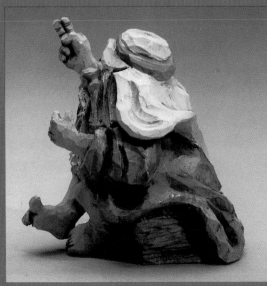

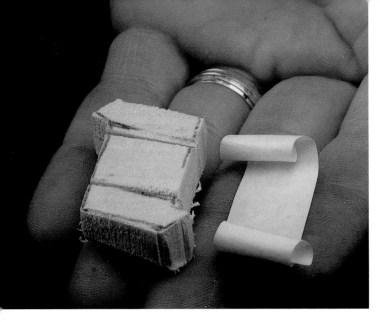

Here's how we make the scroll for Noah's hand. Take a strip of paper 3/4" wide and 2" long, roll the ends around a 16" drill bit, and then angle the rolled ends out. Trace this pattern on a piece of wood 1/4" thick. Use the bench knife to round the ends of the scroll off. Keep the paper as a model while carving your scroll.

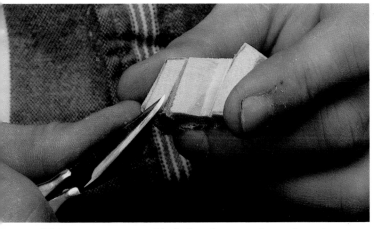

Make two stop cuts with the band saw to show where the rolls in the scroll begin.

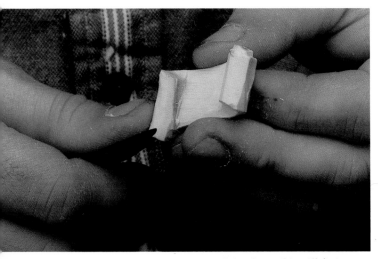

Thin the center down with the bench knife until it will fit in Noah's hand. Round the ends of the scroll and angle in the opposite ends to those sticking out.

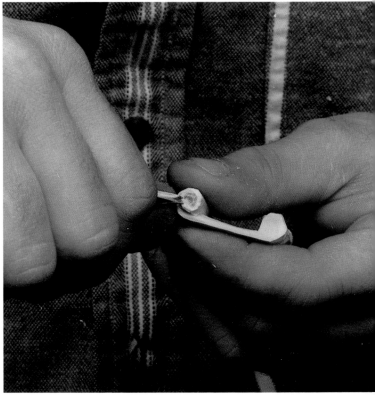

The ends have been rounded and properly angled with the bench knife. To curl the ends, keep the width of the paper consistent and (using your paper roll as a model) follow the shape of the curl. The inside curl is made by using the tip of the bench knife at an angle and cutting as if you were coring an apple. The outside curl is a spiral cut outward. Repeat the process on the other side.

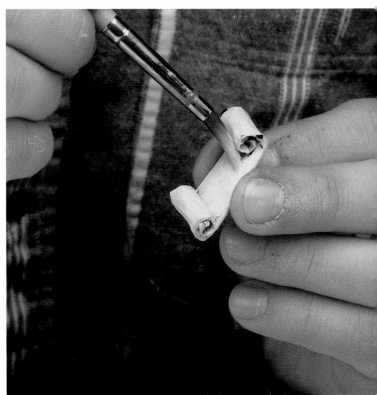

Go back with the wood burner to give the ends more depth and shadow. Then mix white and raw sienna for the basic parchment color.

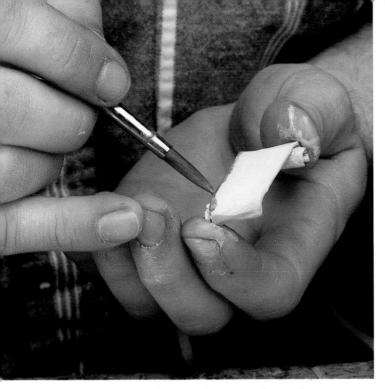

Outline the edges with brown ocher to age the scroll.

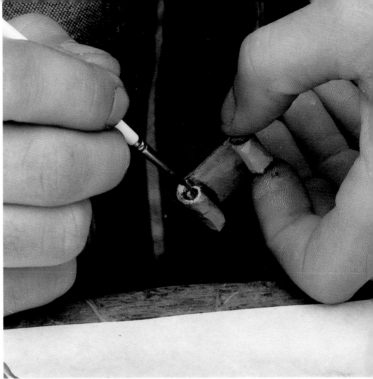

Use the #1 brush to paint burnt umber in the inside curls of the scroll for shadows.

Noah with his scroll. You can fill in the names on the scroll in pencil.

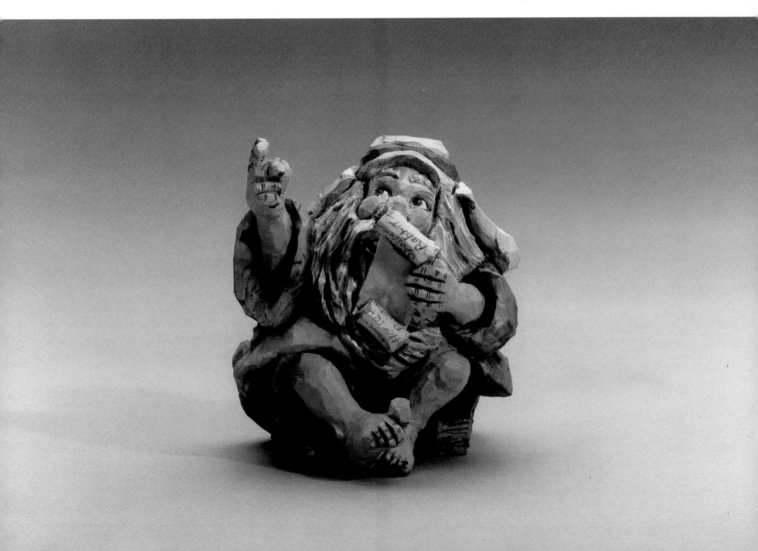

Carving the Elephant

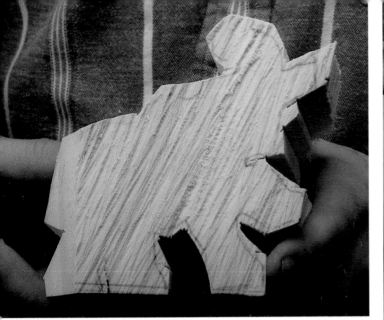

Use a band saw to cut out the basic elephant pattern from a 4" thick piece of white pine. There is no center cut between the feet. This allows them to be more animated, less regimented or statuesque.

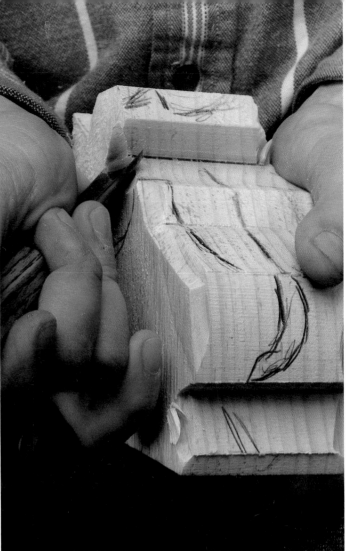

Using a #7 gouge, begin roughing out the block, removing the hard edges and making it more comfortable to hold.

The right front foot is raised, the right hind foot is forward. Seeing as the left leg is the supporting leg, remove excess wood from the right side. This helps define the left leg and free up the underside of the raised right leg.

Establish the center line but angle it off center a little to the right at the head as it will be slightly turned. Also draw the top view of the pattern on the block.

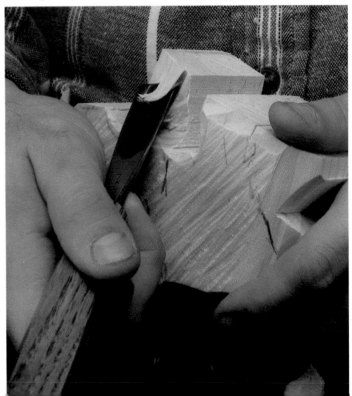

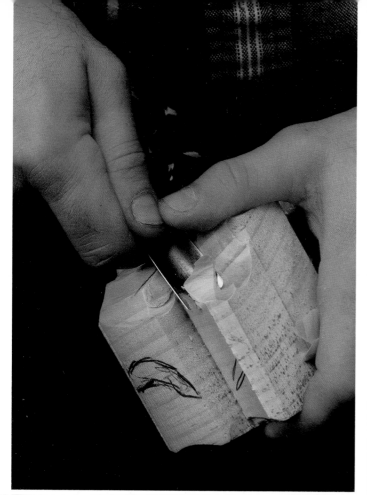

Seeing as the right hind leg is forward we are removing the excess wood from behind the right leg in to the inside of the left leg. We are always looking to show motion. Reverse the process on the other side to free the right hind leg.

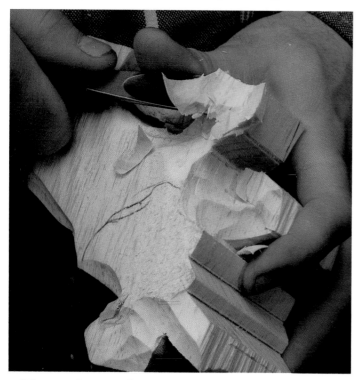

When carving animals, it is important that the legs are carved under the body rather than hanging off the sides. This will give a more realistic stance.

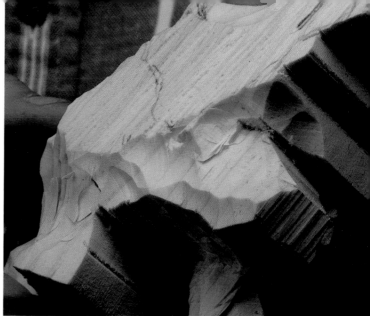

Here are the right legs placed beneath the body.

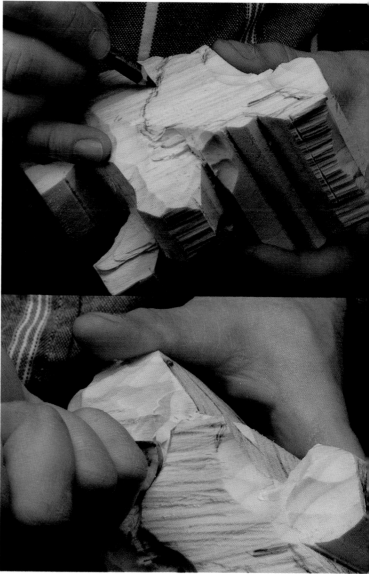

Now the most important thing to do is to find the head. The ears are going to be floppy. Draw in the ear on the side of the body where you want it. First you want to recess the body behind the line of the ear. This way the ears will stand up.

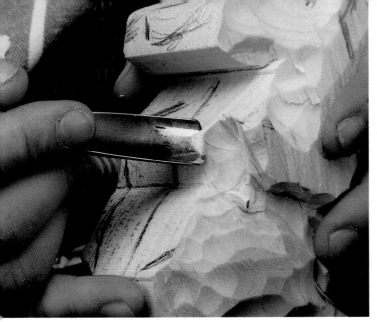

This is the way the undercut ear should look. The body has been recessed away from the ear.

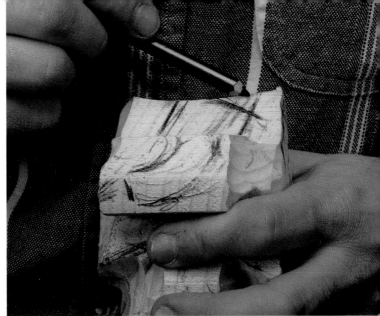

The head is angled to the right. Now establish where the trunk and tusks are going to be. This is the widest point on the head. Shown here is where the tusks will be and the angle we are looking for.

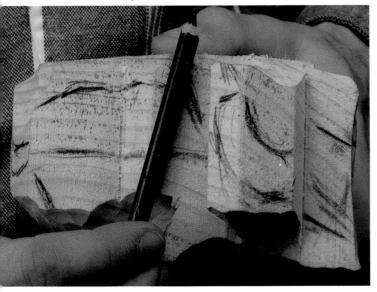

As the head is turned, the left ear will be a little further forward.

As we recess the ears we also approach the shape of the elephants body. The spine is the high point and the ribs fall down away from it. The body is not a block or rectangular shape. With the right rear leg forward and the left rear leg back, there is a shift in the hips. Between ears and hips we have two intersecting lines that give this elephant motion.

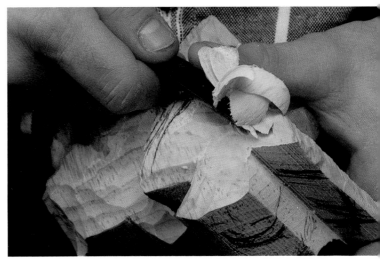

Draw in the inside of the outer edge of the ear and start carving from there in toward the tusk. The inside of the ear is dish-shaped. Begin to establish this shape as you work forward.

The trunk is going to be raised and turned to the outside left in something of an S curve. Establish where the trunk will be, following the lines of the trunk you laid in earlier. Leave the trunk as far left as possible at the top and as far right as possible at the bottom.

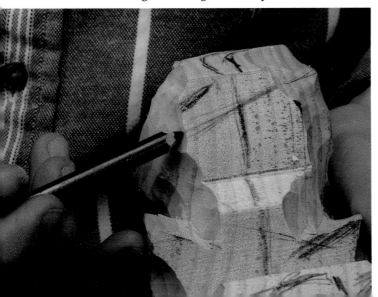

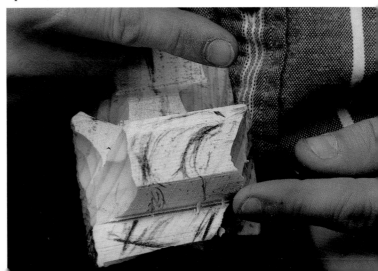

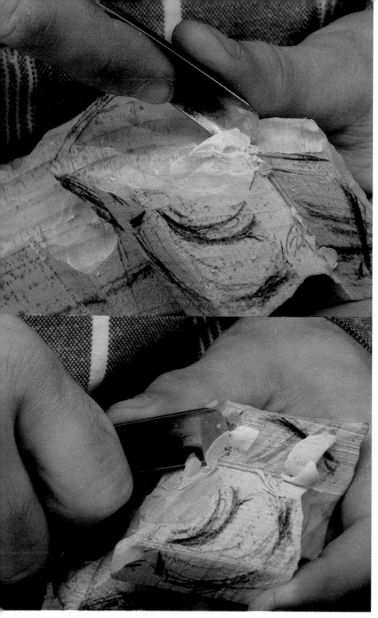

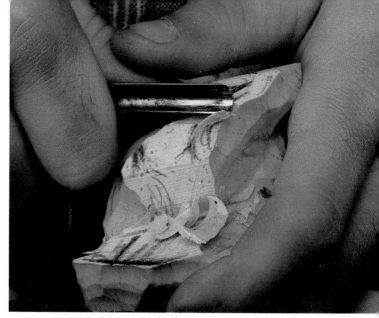

The head is actually the narrowest portion of the elephant. Switch to a #8 gouge and carve the curvature in the trunk. We don't want this to get too narrow and fragile but we want to establish it to get to the head behind it.

A small stop cut is going to establish where the tusk joins the head. From the stop cut we are going to curve the tusk upward a little bit.

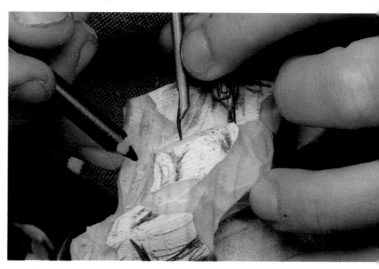

Make sure to establish the width of the trunk at the base, its widest point.

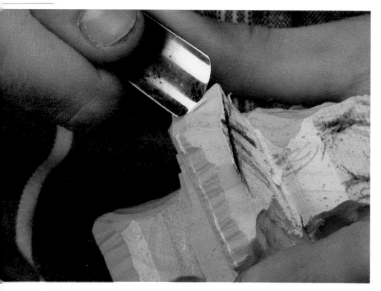

Bring down the tusk to the angle we drew along their leading edge to keep them equal in length.

Using the #8 gouge, shape the back of the trunk where it blends into the head.

The top of the ear is going to be the widest part of the elephant and the bottoms will be closer in to the body.

Bring in the bottom of the ear a little more to give it some distinction.

The hump between the ears in the pattern allowed for the height of the ears. Now lower the hump to where the two lines on the inside of the ear are coming into the head. This will give you the top of the head. Get as many photos of elephants as you can for reference material. The more references you have around you the better your rendition of the animal will be.

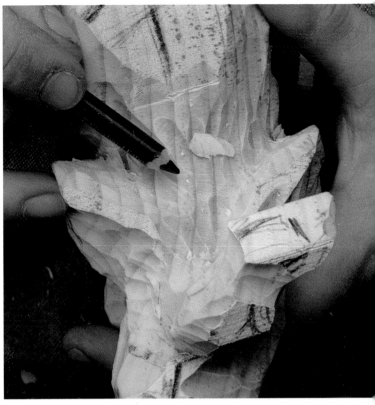

Here is the head reduced to the level of the ear attachments.

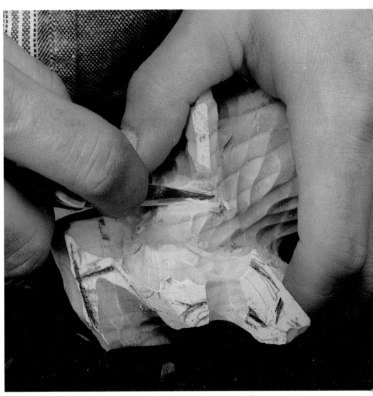

Using a bench knife, establish where the ear will connect to the head. The ears connect along the side of the head, not off the top. Cut narrow — leave excess wood, you can widen the gap later if need be but you can't put back what you have removed.

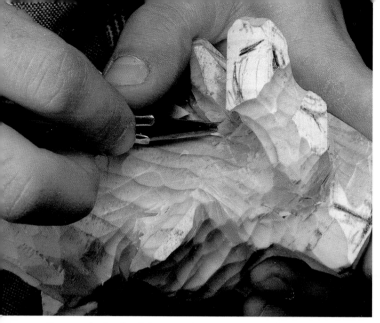

Cut out the back of the ear where it is going to connect to the head. Make a V cut with your bench knife to give a little more separation behind the ear.

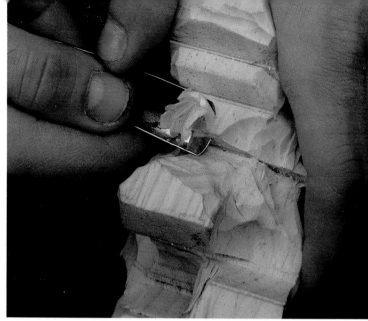

Carve out where the neck is going to flow down into the chest. Round it down and get it centered.

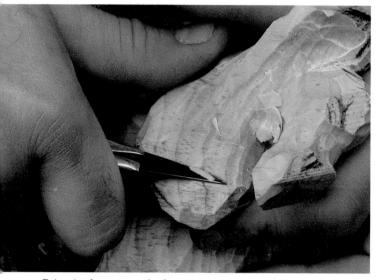

Bring in the ear canal where it is going to meet the head, making a curved knife cut. As with human ears, this ear canal funnels sound into the ear and should be on the same line as the center of the eye.

Using the #7 gouge, thin back the inside of the ear so there will be room for the eye.

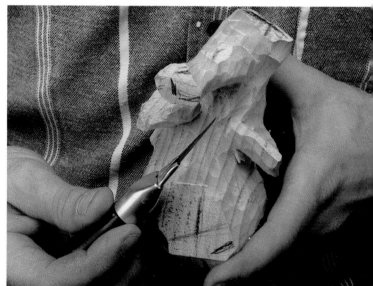

When working on the head, it is important to look from the top view to make sure your angles are correct. For instance, the ears shouldn't be on the same plane when the head is turned.

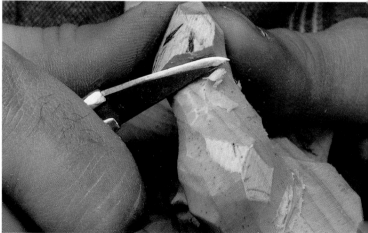

Thin out around the tip of the trunk to make the end look more like a trunk. This will also minimize the possibility of the end flying off. The trunk is a big, tapering muscle.

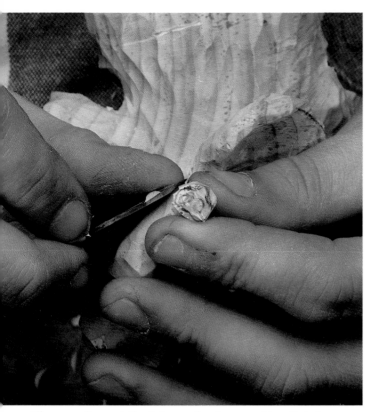

These are the nostrils of the trunk to be carved in a little later.

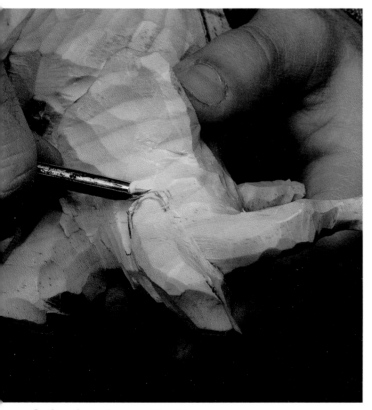

Outline the tusk area with a #9 gouge.

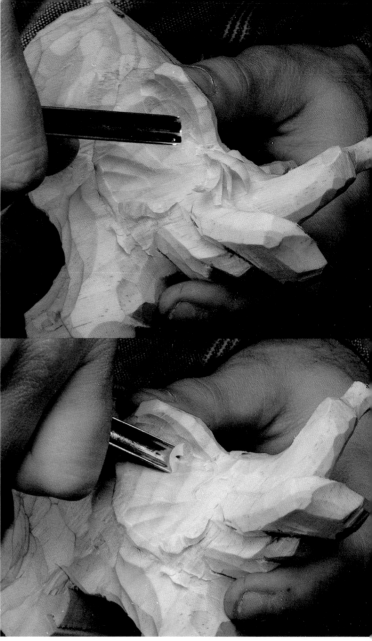

Undercut the leading edge of the ear with a #8 gouge.

Let's make the ears floppy. Top and bottom cuts leave a high spot in the middle which gives form to the ears. Three cuts are used with a #8 gouge, one above and below along the front of the ear and another cut behind the ear.

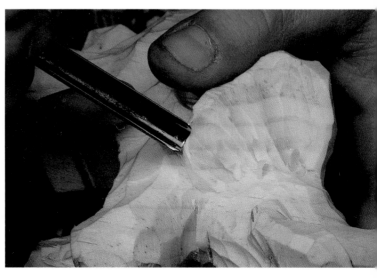

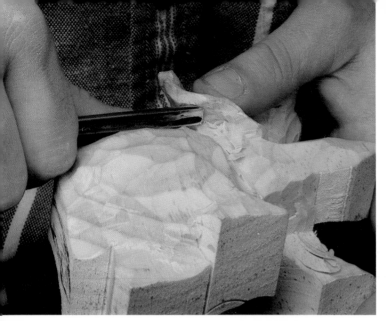

Here is the cut from behind the ear in the center rise.

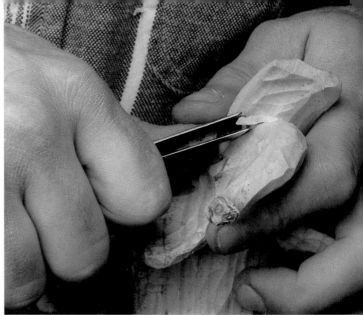

Use a veining tool to define the trunk and tusk connection. Make a rounded outline cut for the underside of the trunk and the top of the tusk.

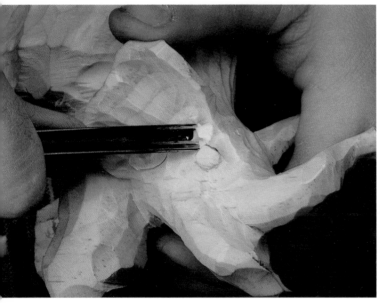

The eye views ahead and behind by protruding from the head. A mound must be created for the eye. To make the mound, use a #8 gouge and cut around to create a little pitcher's mound in the head. Reduce the surrounding wood until you are left with the mound.

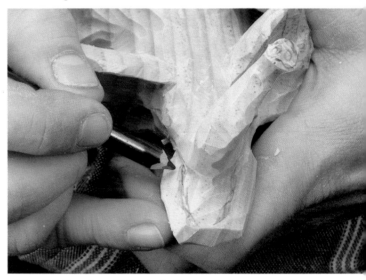

Now it is time to split the tusk. First make two rounded pencil marks right underneath the trunk, tusks don't grow straight out, they curve inward and so will our marks.

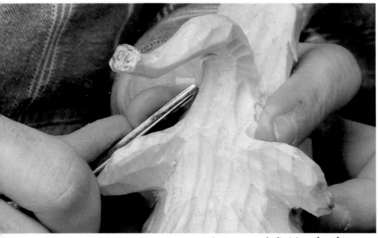

The top cut above the eye mound gives us definition for the top of the head.

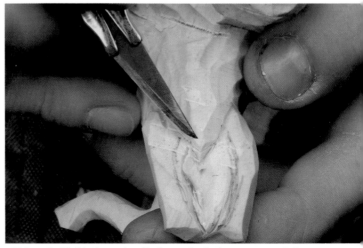

Take a knife blade and split the tusks, being very careful to make two precise cuts that meet in the center. As you remove stock, be sure to leave a little V here for the lower lip.

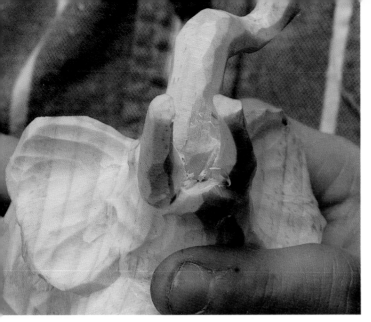

Here are the separated tusks and the lower lip. We will leave them like this for a while.

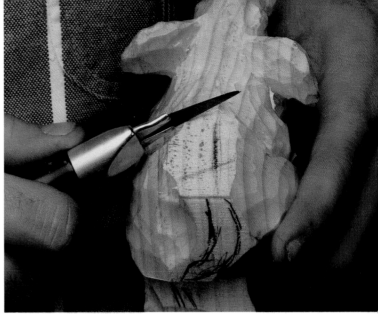

Repeat this process on the other side, keeping in mind the angle of the hips from the pencil mark made before.

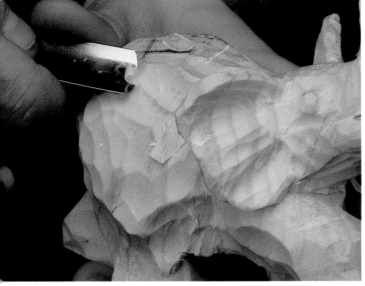

Round down the body using the #7 gouge.

Using a #8 gouge, make a deep depression near the spine above the right rear leg at the top of the back to accentuate the hip, showing the bone and giving the elephant motion. Move down the front of the leading right back leg with a bench knife to separate the leg from the body.

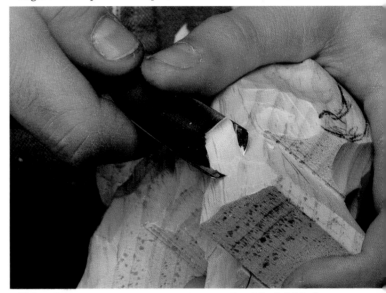

Using the #7 gouge start carving the outside of the left hind foot.

Elephants are narrower in front than in back — narrower in the shoulders than in the brisket or the rump. We will try to capture that now. First draw in pencil lines to follow. We draw a mound in the shoulder to show muscle and remove the wood from beyond the pencil line. This shows the transition between the shoulder and the leg. Using the #7 gouge, thin down the front shoulders so the belly will look larger.

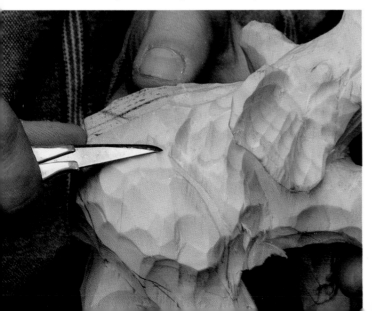

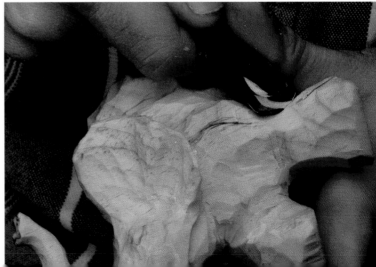

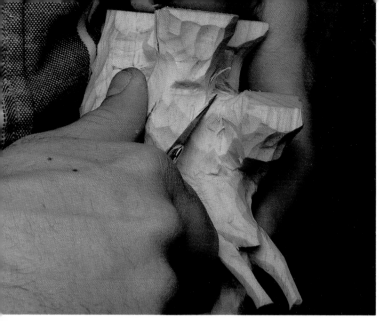

Now blend the front shoulders into the breast bone with the bench knife. The legs are separated by this bone. Continue to round the legs, both along the inside and along the backs to the final shape with the bench knife as well.

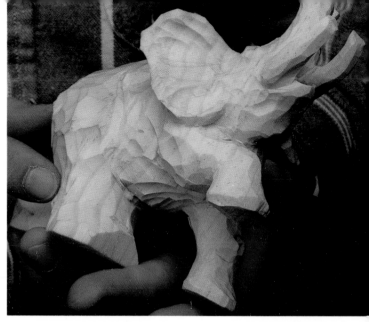

Here is the raised right front leg as it is being rounded down.

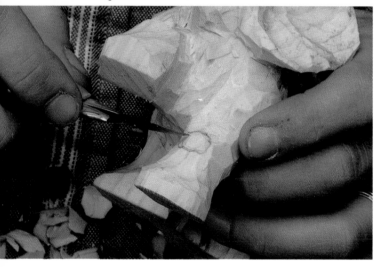

As you round down the leg leave a little mound for the knee as shown here.

The left front leg is now being shaped and rounded from the inside, and the outside. The knee mound has been left. Note how the leg is underneath the elephant to bear his weight and not out on the side. Continue on to the other legs, rounding to create the proper form with the bench knife.

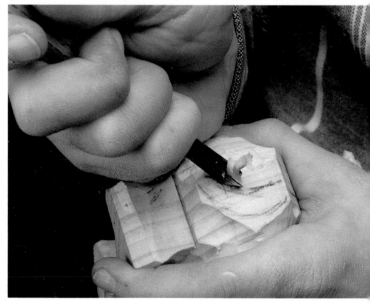

Now use the V tool again to outline the thin tail.

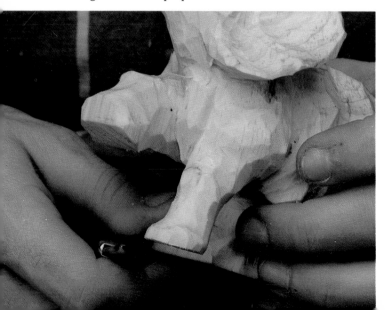

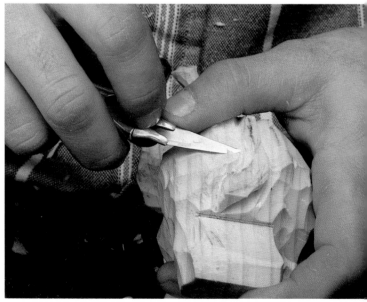

Round the rump away from the tail with the bench knife.

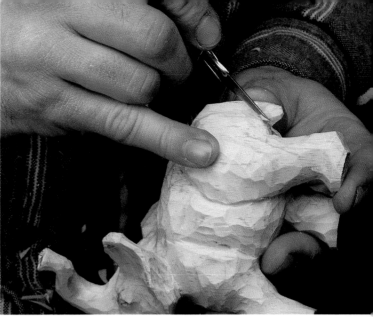

Use the bench knife to separate the tip of the tail from the rump.

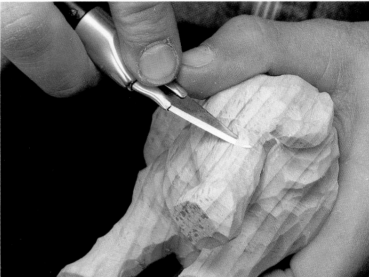

Here are the rounded back legs. Note how the trailing leg crosses the center line and the shift in weight on the rump creates a feeling of realism.

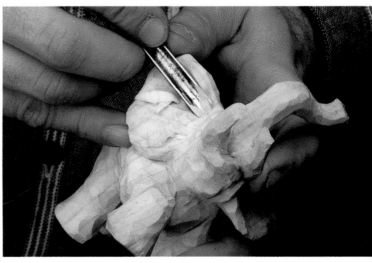

Now go back and clean up all around the elephant. Look to see that all the cuts, forms and transition areas are clean.

The rump is being rounded off with the bench knife on the right side. The top of the pelvic bones have been carved in by following the line of the tail to the head. Leave the center raised for the spine and leave two little lumps on either side of the tail for the pelvic bones. Now we will work on the two hind legs.

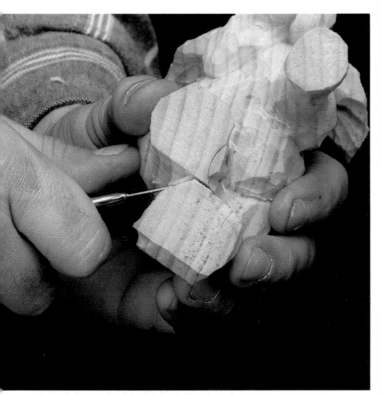

Round down the hind feet, following the same steps you used on the front legs. Be sure the bottoms of the feet are the same diameter on all four legs. These can be measured with a pair of calipers to be sure. Separate the rear legs from the inside, cutting from the pads down toward the belly, rounding the legs as you go along.

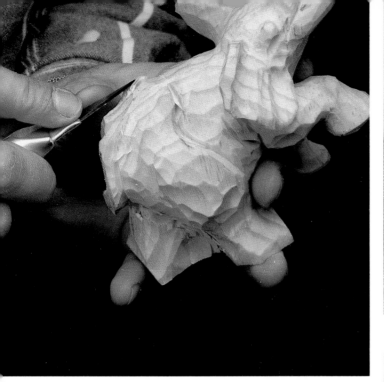

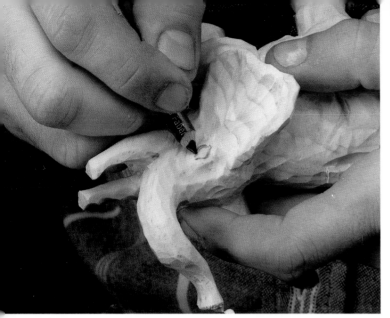

Draw in the eyes.

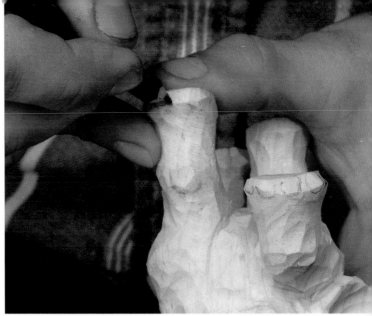

Draw in the toe nails.

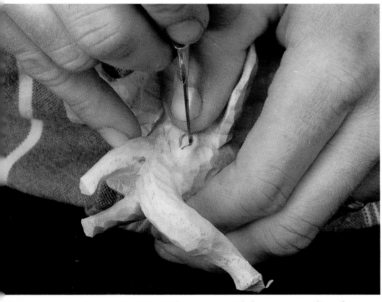

Make a nice deep straight cut around the eye to outline the eyeball.

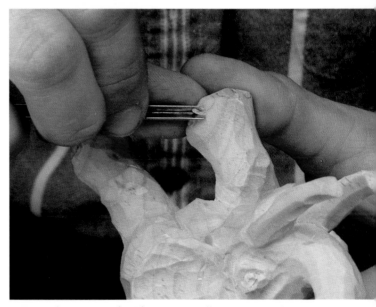

Toenails are carved with a very small #12 veiner. The toe nails are cut with one smooth motion into half circles.

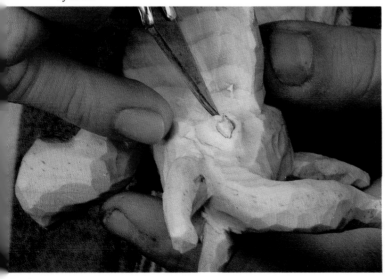

Now use very small knife point cuts angled into the stop cuts to round off the eyeball.

One deep curved cut with the tip of the bench knife creates the mouth.

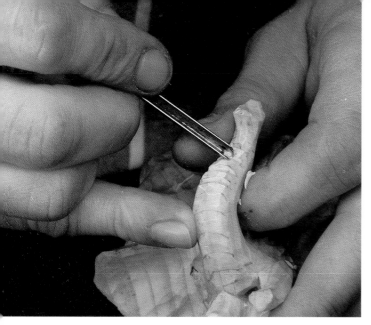

The underside of the trunk is cut with a veiner in a series of even, semi-circular lines running horizontally across the trunk.

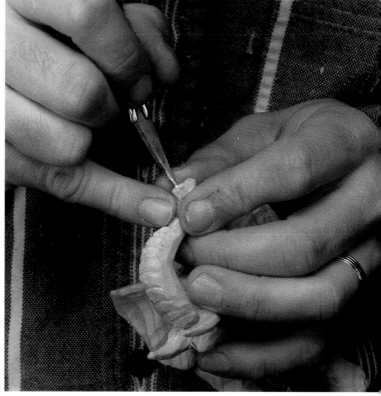

Be very careful when carving the nostrils. Barely stick the bench knife in and make a little hole. Be careful not to break the trunk.

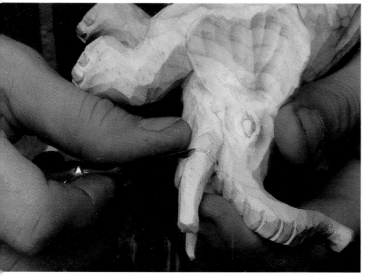

Make a little stop cut along the pencil line where the tusk protrudes through the skin. Reduce the tusk to enhance the appearance.

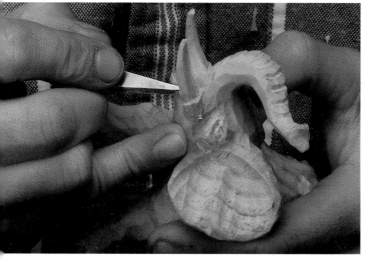

Slimming down the tusks is one of the last things done as they are the most fragile.

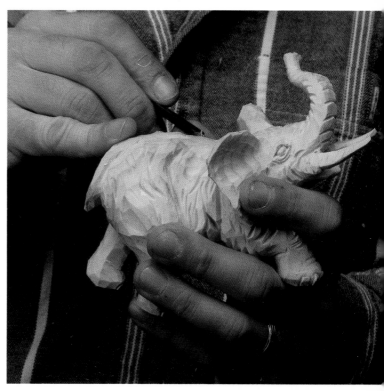

Now we have come to the fun part of the project, putting on wrinkles with the #12 V tool. Wrinkles can go just about anywhere and look good...on an elephant. Wrinkles are just little V shaped lines with curves in them. Wrinkles in the skin should not be straight. How many wrinkles you choose to put in and in what pattern is strictly up to you. Especially apply them around the eyes, trunk, and face. The neck is also a good place for a lot of wrinkles.

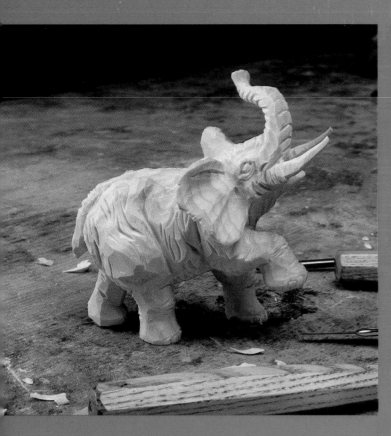
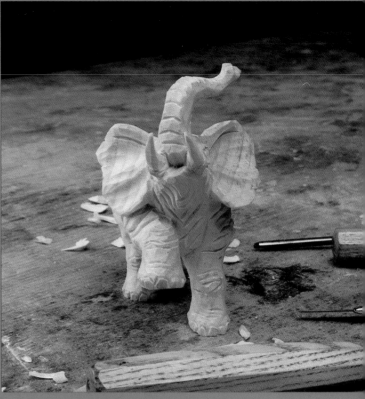

Here's the elephant ready to paint.

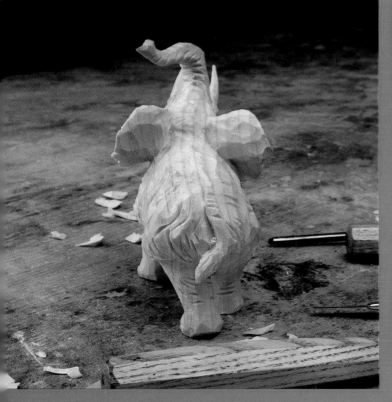
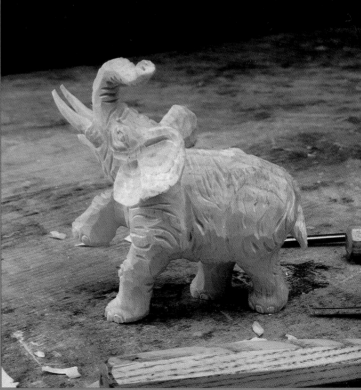

Painting the Elephant

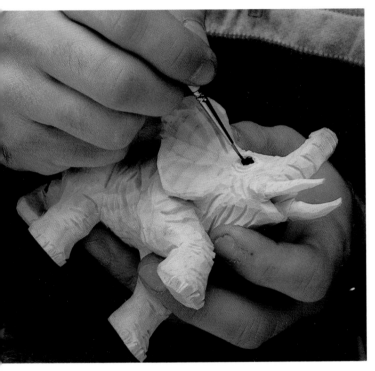

We're going to paint this elephant with pale white, raw sienna, raw umber, and ivory black mixed with Minwax natural to create our stain washes. I mix the white with a little black and the burnt umber. Just a touch of ultra-marine blue. This provides a nice gray tone to start as the base color for the elephant's body. But first let's paint the eyes black.

Now apply the gray wash to all but the toenails and the tusks. To keep from getting a monotone color I will be picking up small dabs of burnt umber, black and ultramarine blue to vary the shading as I go.

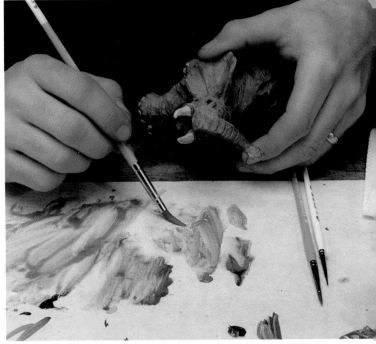

For the underside of the trunk take a little cadmium red, thin with Minwax, mix with raw sienna and warm sepia. Paint the underside of the trunk. Immediately go over this with the gray used on the body. Paint the lower lip the same way.

Mix up white with a very light touch of sienna to make a very pale ivory color. It appears creamy yellow and is applied to the tusks and toenails.

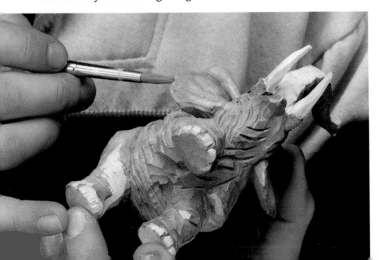

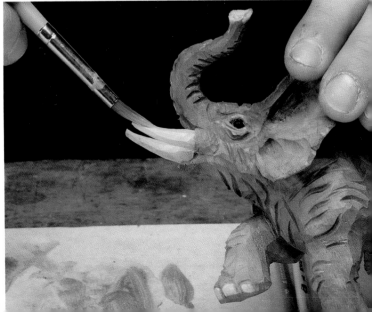

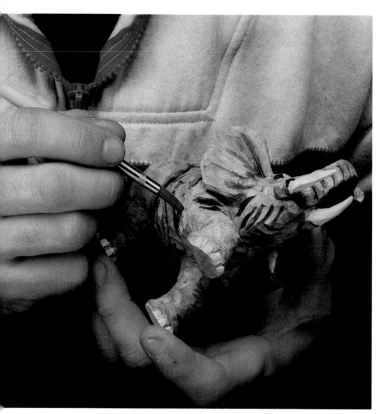

Take a little raw umber, a little Van Dyke brown and use this in a light wash in the wrinkles. Vary the amounts to provide variations in texture and shadows in areas such as behind the ears.

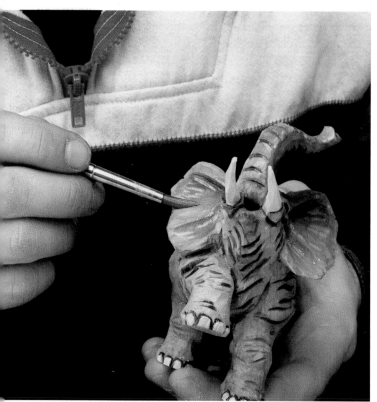

Use a very light red wash in the ears as well by using the same paints you used on the inside of the trunk and the lower lip. Blend this light red with a thin gray wash.

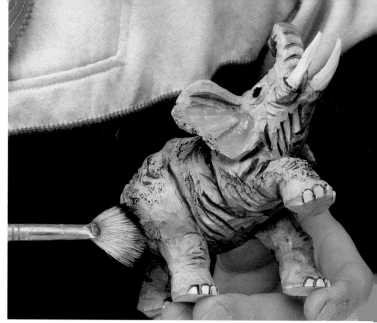

Now comes the fun part. Take a Langnickel fan blender brush and, just using the tips of the bristles, pick up a little unthinned black paint and stipple little black dots on the elephant. Just dab the brush against the elephant.

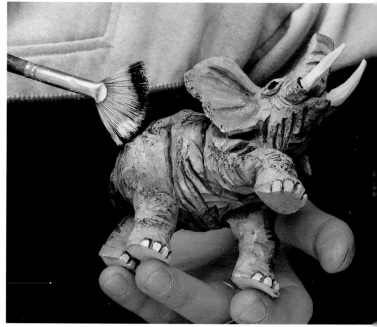

Take a little white and do the same thing, highlighting raised areas you feel are appropriate.

Use a tiny #1 brush and put a little white on the tip. Place a little white dot on the eye above the centerline of the eye, forward or back but never in the center of the eye.

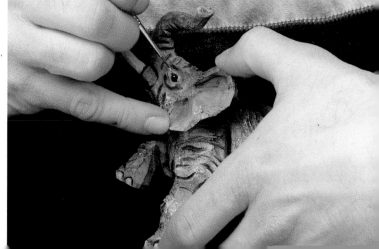

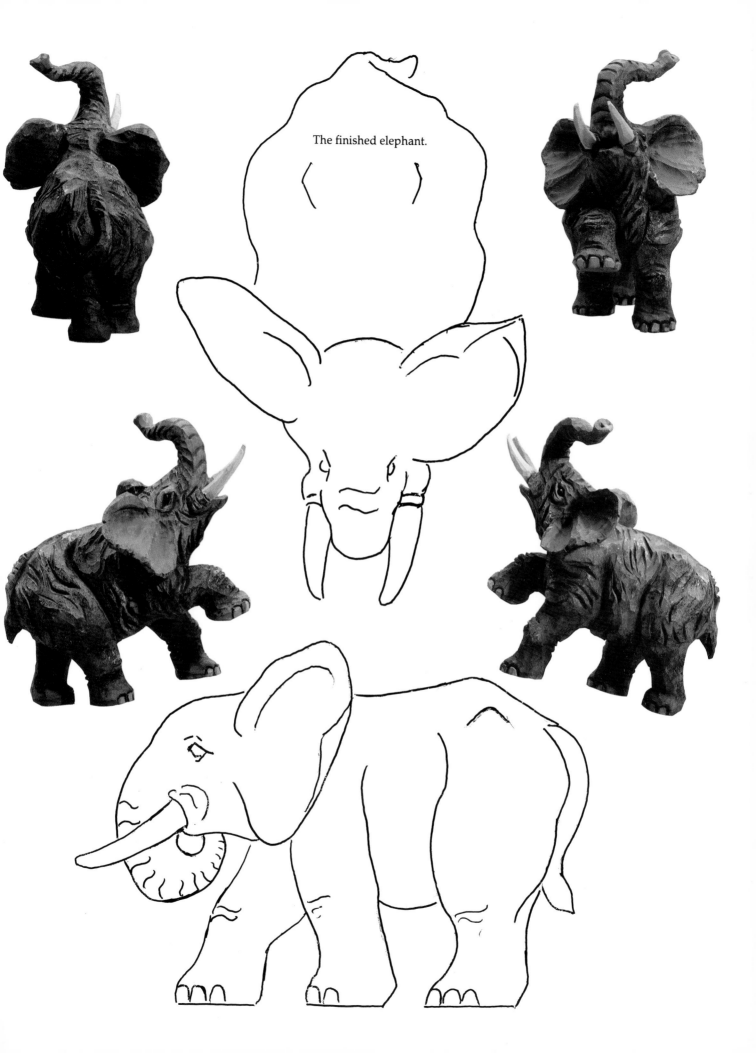

The finished elephant.

Carving the Giraffe

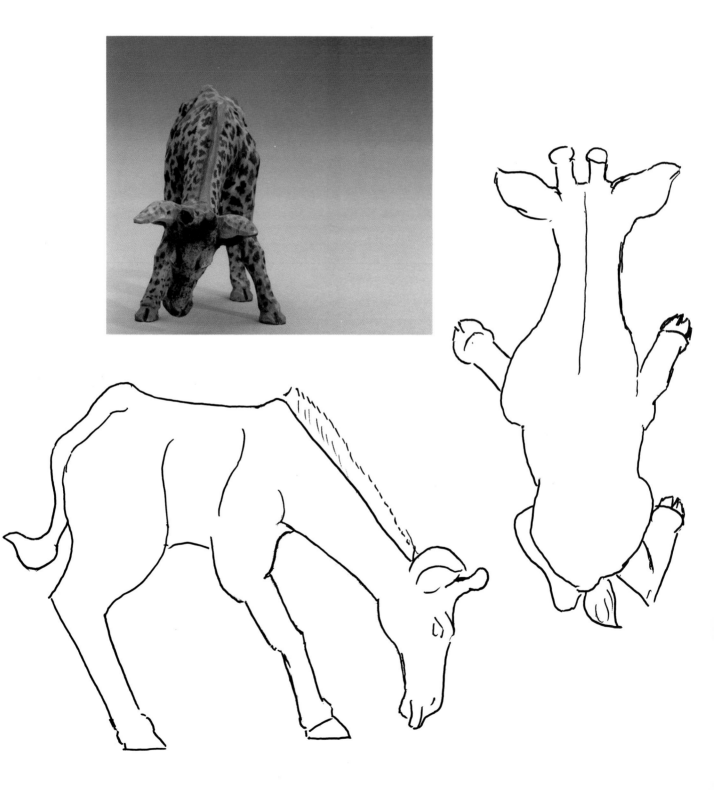

Thin down the neck with a #7 gouge.

This giraffe creates some tricky problems, the feet are spread wide, the head is between the feet, and the block needs to be 2 1/2" wide to take account of the spread of the front feet. With the head lowered you can't run the band saw up between the legs. This extra wood must be cut away. Once you have your blank, draw the top and side view patterns on the block and establish your center line. The head will also be angled slightly to the right, so adjust your center line accordingly. Using a 1" #5 gouge, begin to round down the blank. Narrow the shoulders and remove some of the excess wood from the head first. The giraffe is slender and elongated with two little protuberances (horns) on top of the head. Don't forget those are going to be there as you round the blank. Once you have the head roughed out, move on to those horns before you forget and have to add them as separate pieces later.

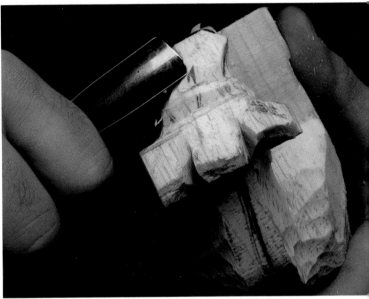

Follow your pattern when slimming down the nose with the #7 gouge.

First make two deep angled stop cuts, one angled to the outside, toward the ears, and the other straight down along the horns.

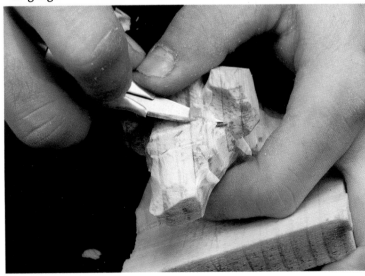

Further reduce the head with the bench knife. A giraffe's head is very narrow.

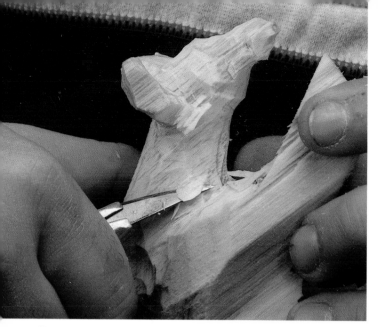

Continue to round down the neck with the bench knife as well.

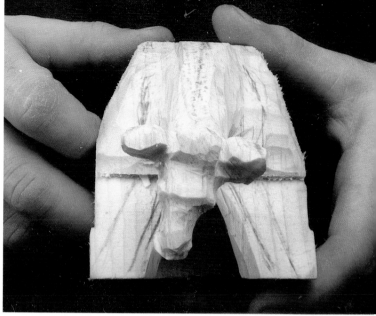

Pencil in the lines of the outer edges of the front legs and the shoulders.

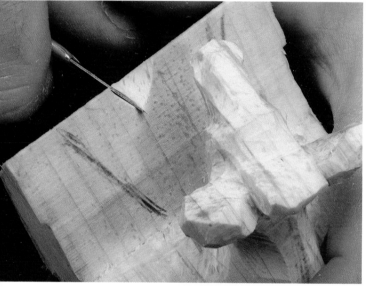

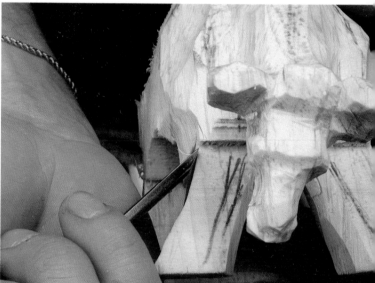

The head and neck are well established. Let's move on for now. We don't want to remove too much wood just yet as we have a lot to do and we don't anything to break. Now we'll cut the space between the two front feet. The front feet are angled outward from the chest. Draw in the inside line of the front legs. Then take the bench knife and, starting in the center, make V cuts to remove excess wood.

Enough of the excess wood has been removed from the front legs for now.

Use the 1" #5 gouge to bring the front knees closer to the body and to give the giraffe it's stance. Continue up to the shoulders to thin them as well.

Using the V tool, establish the back of the front shoulders as well.

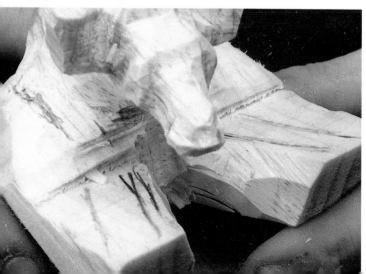

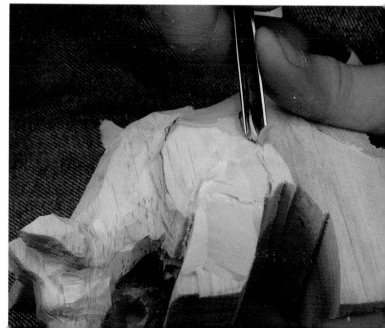

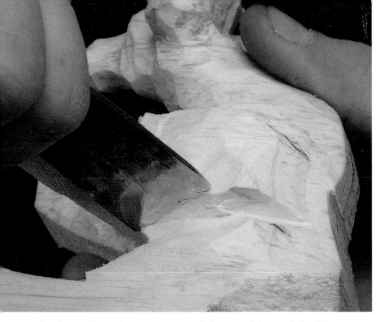

Further reduce the wood around the shoulder and the V cut behind the shoulder with the 1" #5 gouge. Taper the shoulders up toward the top of the spine.

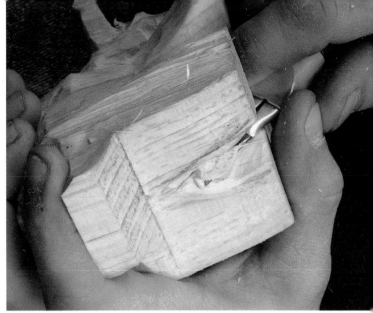

Draw in the inside lines of the rear legs and separate the legs, tapering up into the tail. The hind feet are not as wide spread as the front, keep them 3/4" wide at the inside of the foot. Use the same V cuts as were used on the front legs.

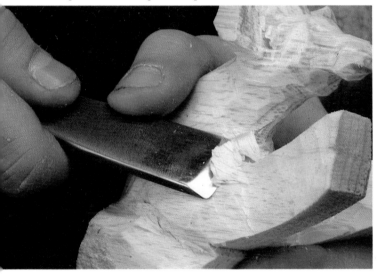

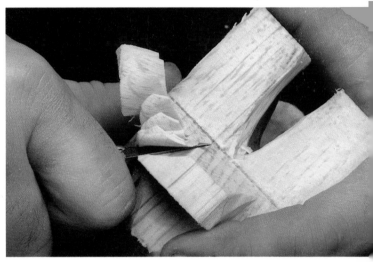

Invert the 1" #5 gouge and use the inside radius to round off the sides of the shoulders where they come to the joint of the neck. This will make a nice gentle rounding.

The shoulders were wide and muscular but the hind quarters narrow. Right now we have a lot of wood back there over those hips. Use the 1" #5 gouge and start tapering the hind quarters. The spine is the high point and the flanks taper up to it.

While we're here, we'll begin thinning down the tail as well.

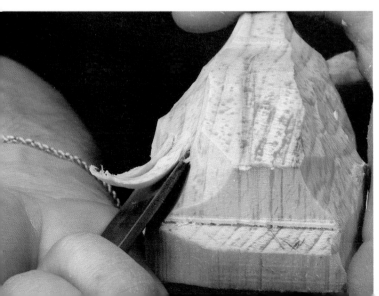

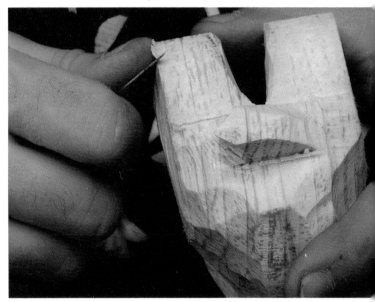

The tail is thin enough at this point for now.

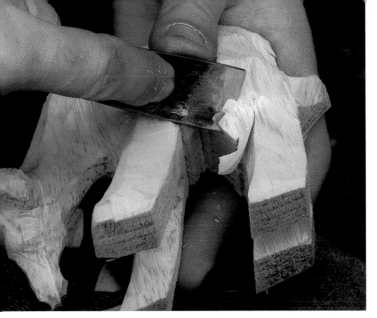

Begin thinning down the outside of the legs as well with the 1" #5 gouge.

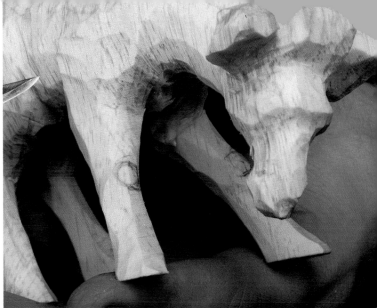

Leave small mounds for the knees of the front legs.

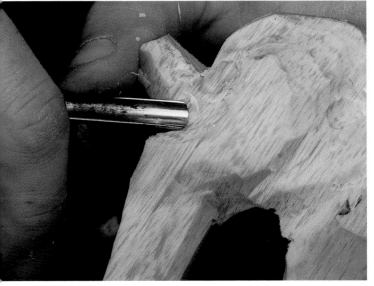

With a #8 gouge make a curve from the top back of the rear knee up into the rump to create the knee and upper thigh. The result should look like this.

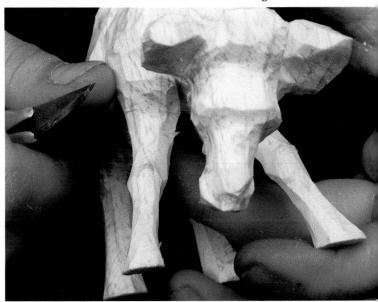

Here are the knees.

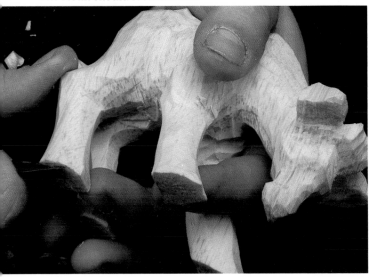

Using the bench knife, continue thinning down all of the giraffe's legs.

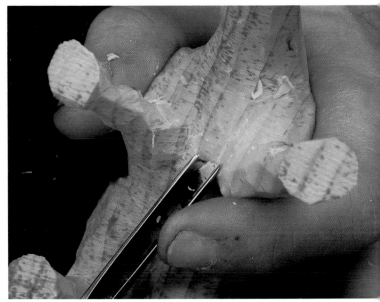

With the #15 V gouge, make cuts along the inner edges where the front legs meet the chest to create the sternum.

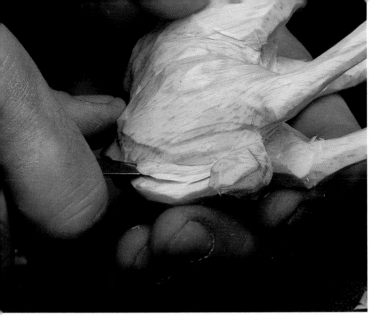

With the bench knife, thin the tail down and leave a little tuft of hair at the end. Carve a nice curve in the tail for motion.

To create the lower jaw, undercut the front from the upper lip with the bench knife and ...

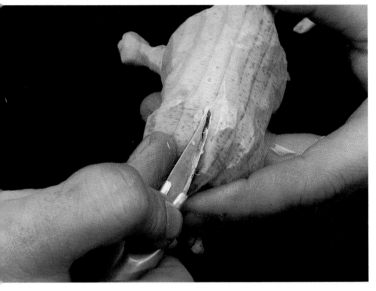

Use the knife to make two rounded cuts on either side of the base of the tail to create the ends of the pelvic bones.

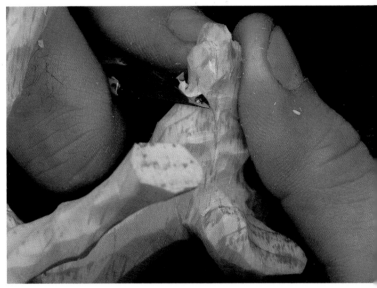

... make a gently curving arc to create the mound of the lower jaw.

Create a little curve down along the outer edge of the lips and then turn up a little to the front of the nose. This is not a straight cut. It has a little flair to it.

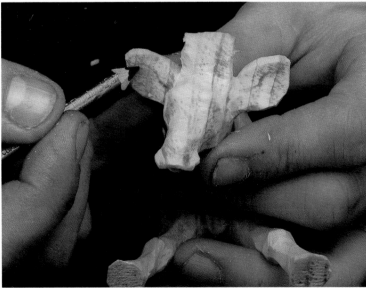

Make some pencil guides for the insides of the ears ...

... and make a cut along the pencil lines with the bench knife, but not too deep or you will go through the ear.

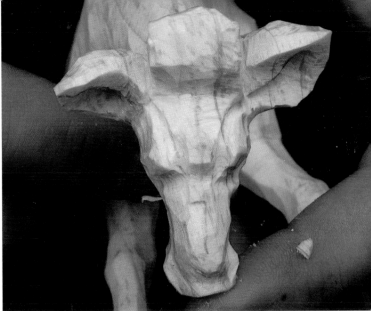

The eye sockets should look like this.

A second gently sloping knife cut up to the stop cut completes the inner curve of the ear.

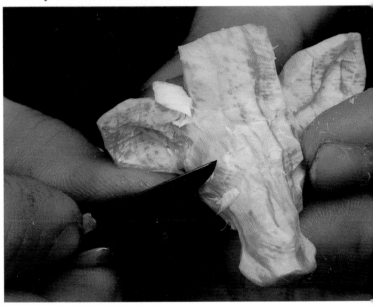

Angle the eye sockets with the bench knife.

Make two little cuts about 1/16" wide on either side of the center line to create the eye sockets.

Draw in the eyes. Take the tip of the bench knife and cut straight in along the pencil lines.

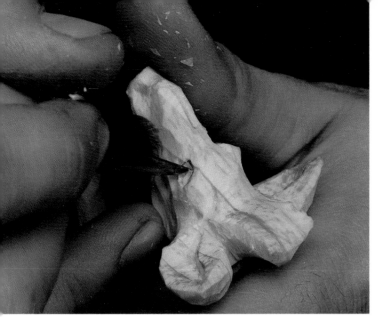

Now round the eye, cutting at an angle back in to the edge of the stop cuts.

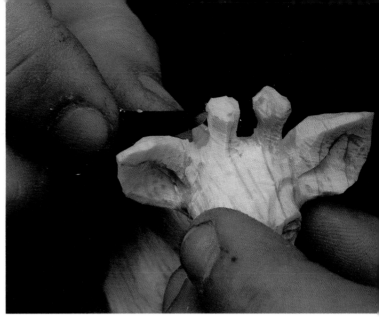

Thin down the horns, leaving the little rounded caps on the tops.

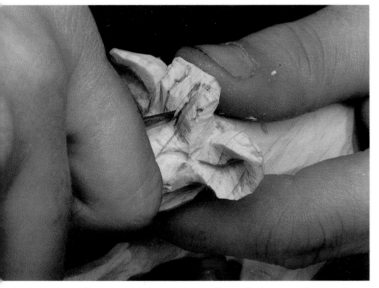

Draw in the horns and make a cut through down to the head along the insides of the lines. The protrusions on top are slightly forward of the ear on top of the forehead.

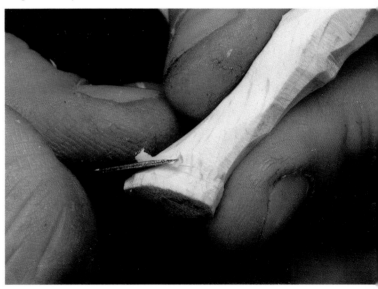

For the hooves, make a little V cut, angling the hooves up into the cut so they appear to be growing out of the lower leg.

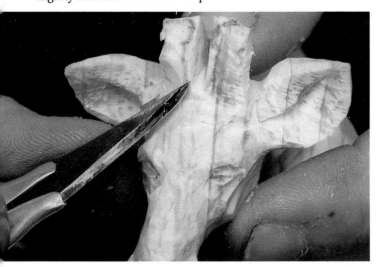

Now carefully undercut at the head and pop the chip out. The horns are separated.

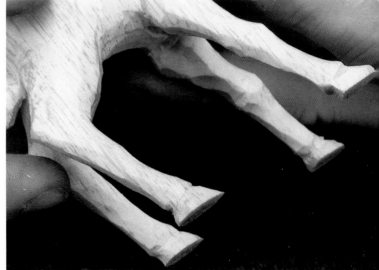

The carved hooves.

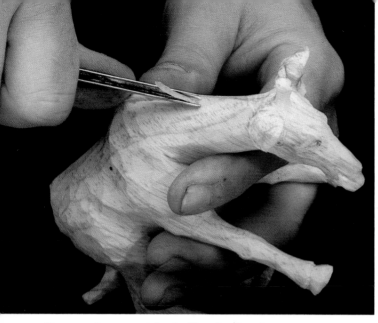

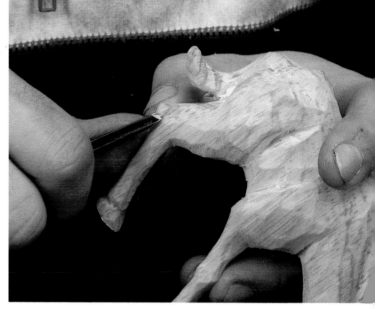

To carve the mane, take the V tool and make two cuts going right alongside the top of the neck. Make it a little bit higher up toward the shoulder and lower toward the head. This creates a properly proportioned mane. The first cut runs right down the side of the neck here. Repeat on the other side.

Make a little V cut along the back of the knee. This creates the tendon there which provides a little more detail without going overboard.

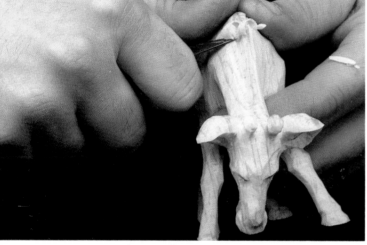

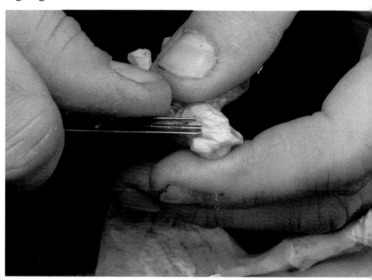

Now take the knife blade and run it up the side of the neck along the cut to reduce the neck away from the mane.

Make two shallow cuts for the nostrils with the V tool.

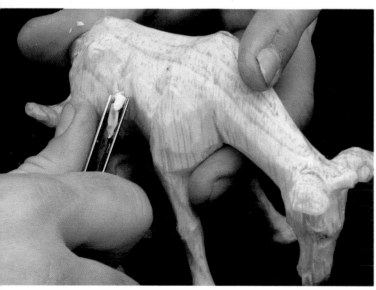

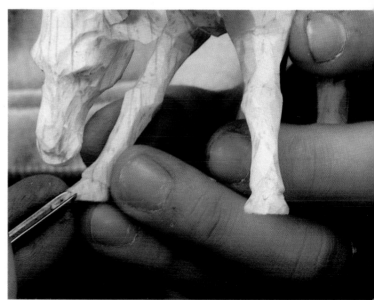

To further accentuate the rump and shoulder areas, use the V tool to deepen your previous cuts.

Split the hooves with the V tool as well.

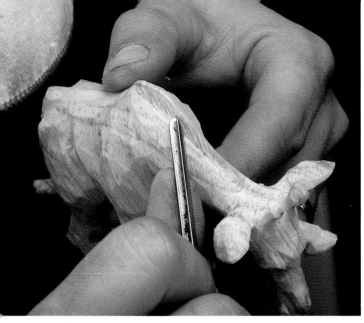

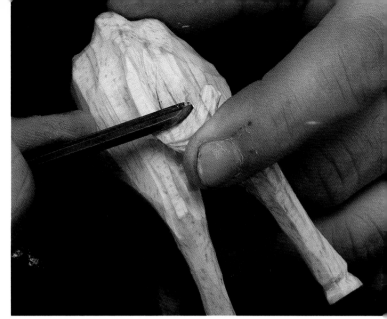

Using the V tool, define the hair in the mane with some small V cuts.

Repeat the process, putting little V cuts for hair in the tail as well.

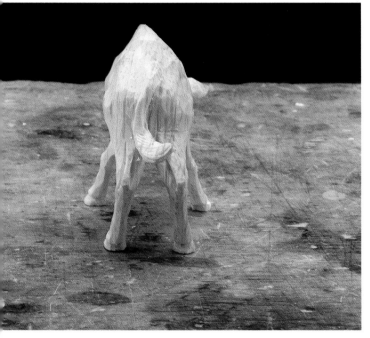

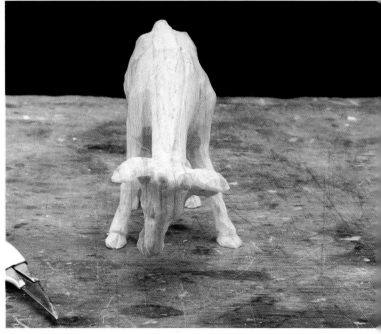

The carved giraffe.

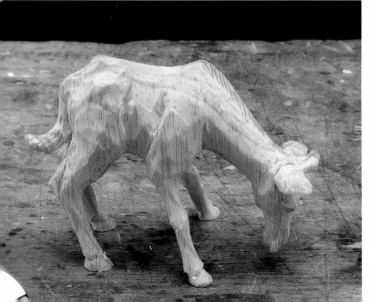

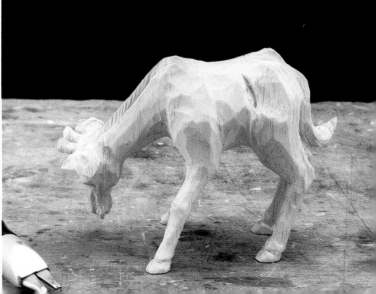

Painting the Giraffe

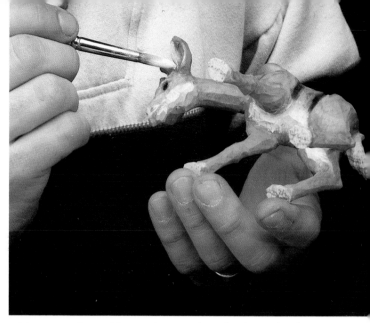

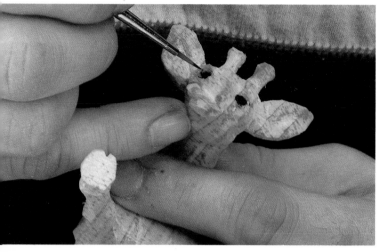

Time to paint this giraffe. Use black, raw sienna pale, brown ocher, warm sepia and white. First paint the eyes black.

Now mix white with raw sienna pale and paint under the chin, belly and on the insides of the thighs. Get up into the ears as well.

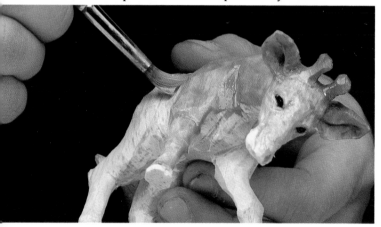

Now mix up the body color, raw sienna pale with a touch of warm sepia and apply over the whole body except under the chin and on the belly.

Use a little warm sepia in the folds of the body, legs and neck to create shadows.

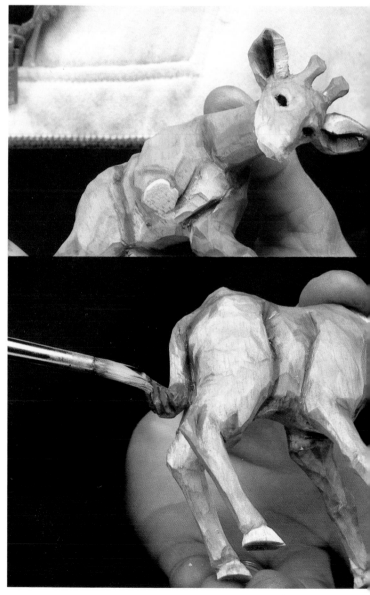

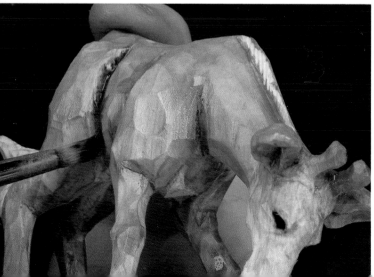

Put a little warm sepia in the ears and on the tail.

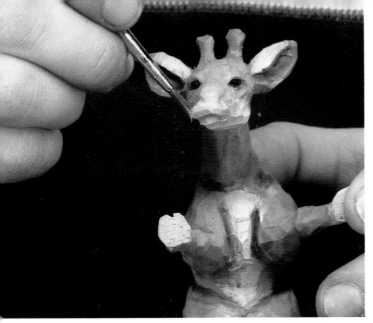

Put a little pale red on the lip and blend it in.

Take the #4 brush and start making patches on the giraffe. The patches should be evenly spaced; however, the patches themselves should be irregularly shaped with some larger than others. Begin at the head with small dots, enlarge them as you head down the neck and into the body, and reduce the patches once again on the legs. We will alternate colors between warm sepia and dark ocher, creating lighter and darker patches. Paint the knobbed tops of the horns with warm sepia as well.

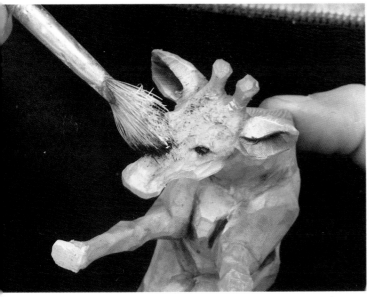

Take the fan blender and dip it in black and stipple from the forehead down to the mouth.

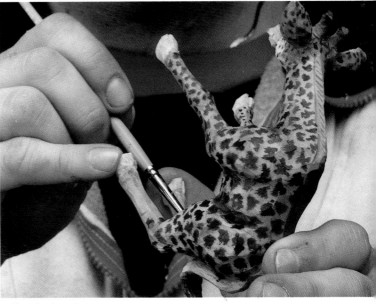

Continuing the spots.

Now paint the hooves with brown ocher.

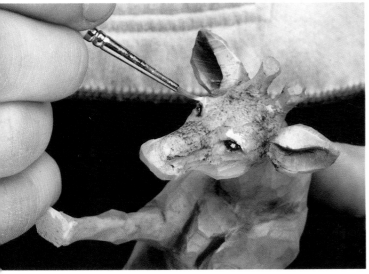

With a little white on the #1 brush carefully put the highlight in the eye and apply a little white over the eyelid.

53

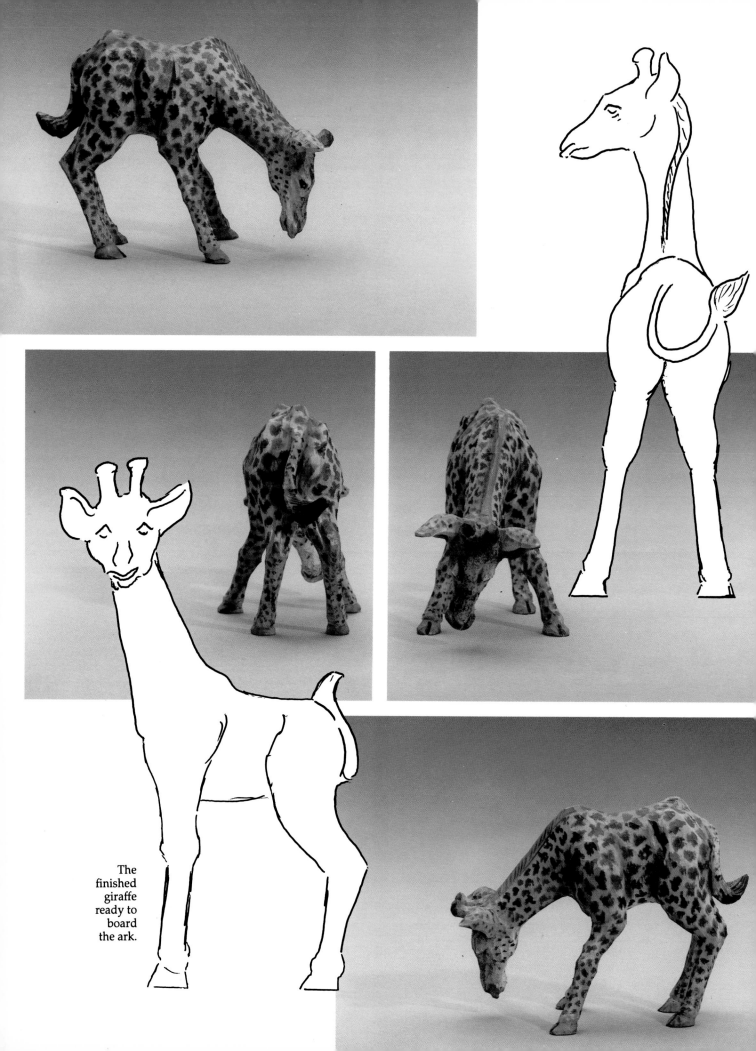

The
finished
giraffe
ready to
board
the ark.

A Gallery of Noah
& His Friends

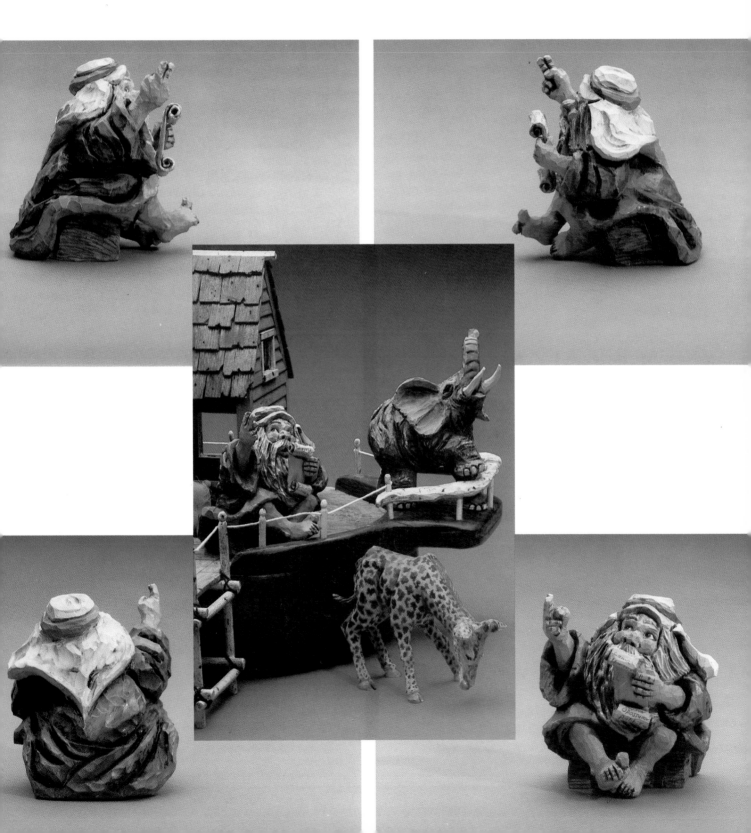

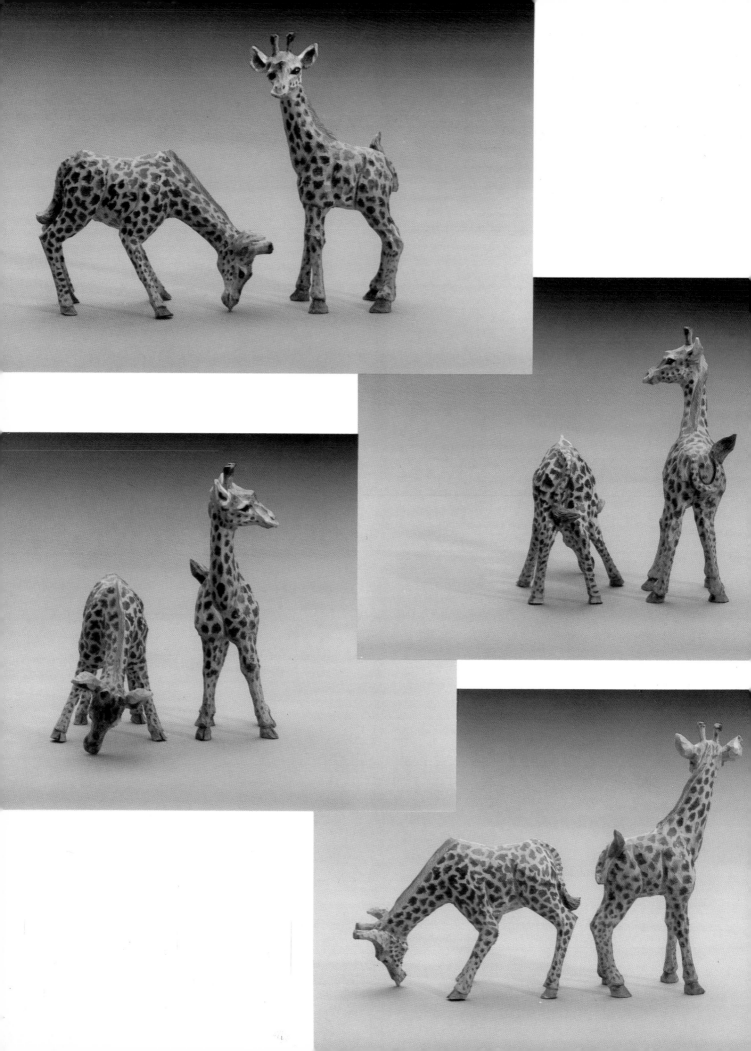

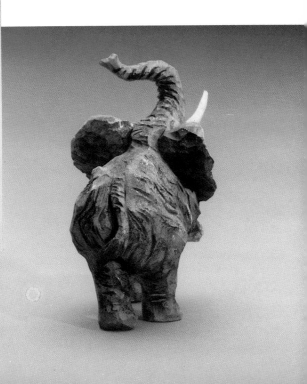

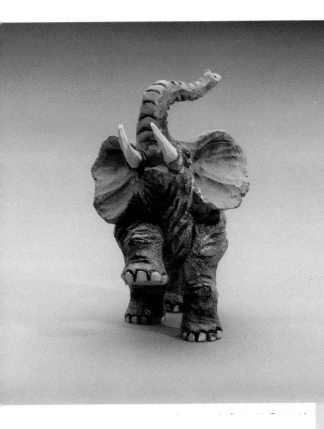

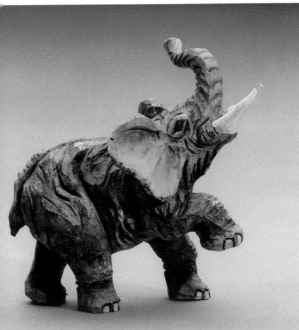

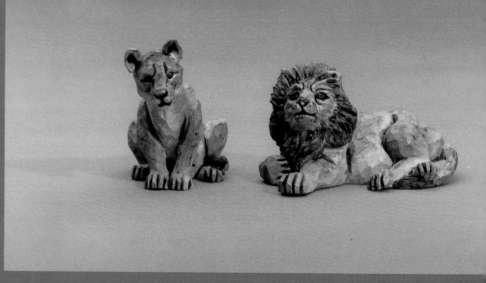

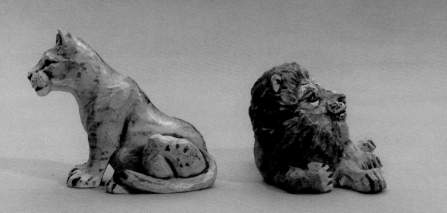

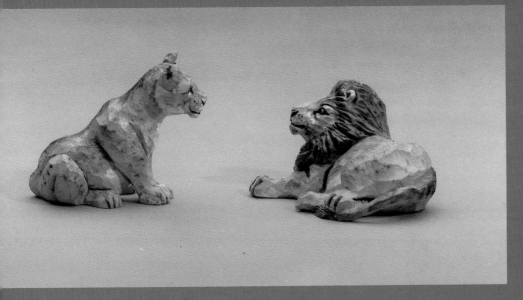

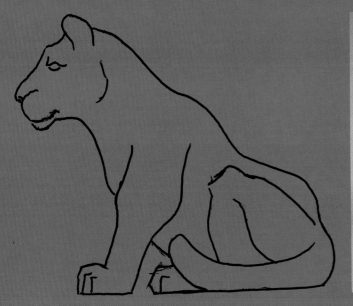

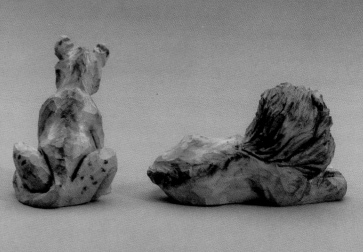

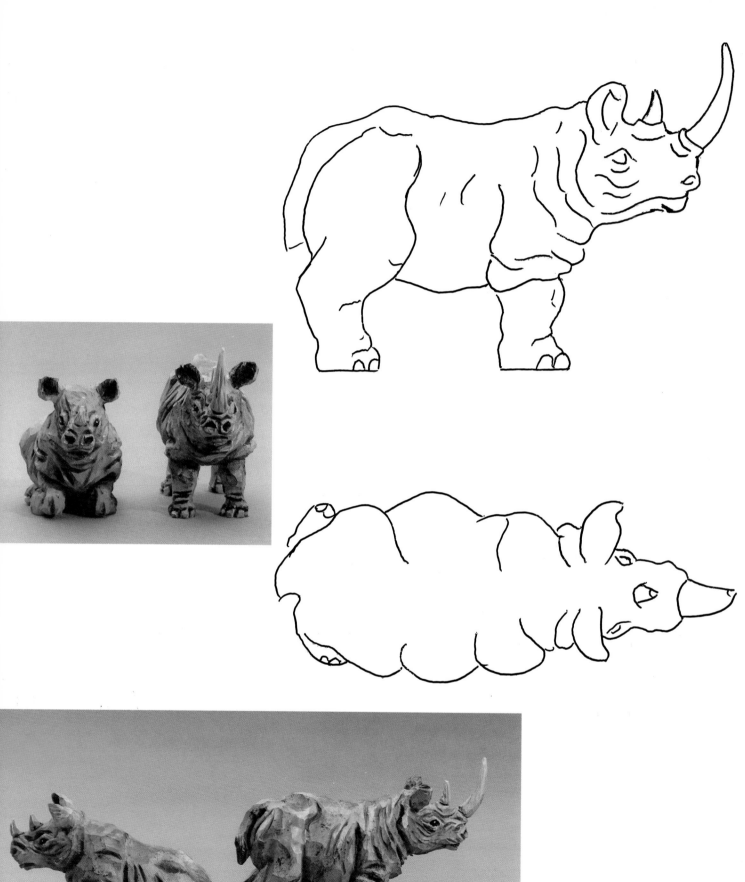

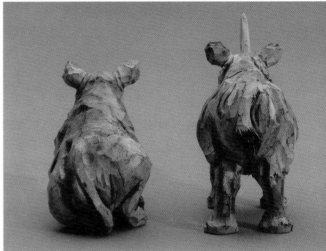

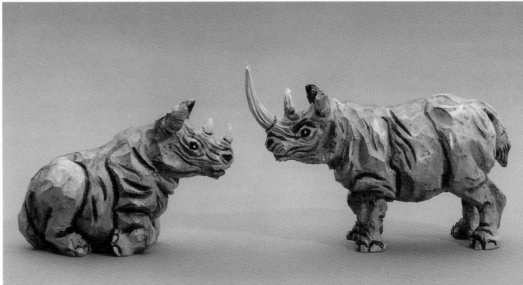

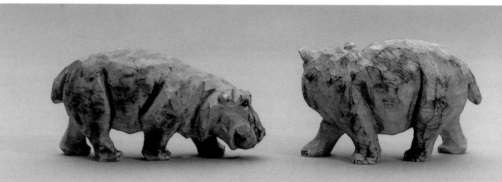

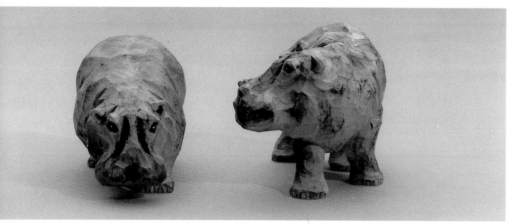

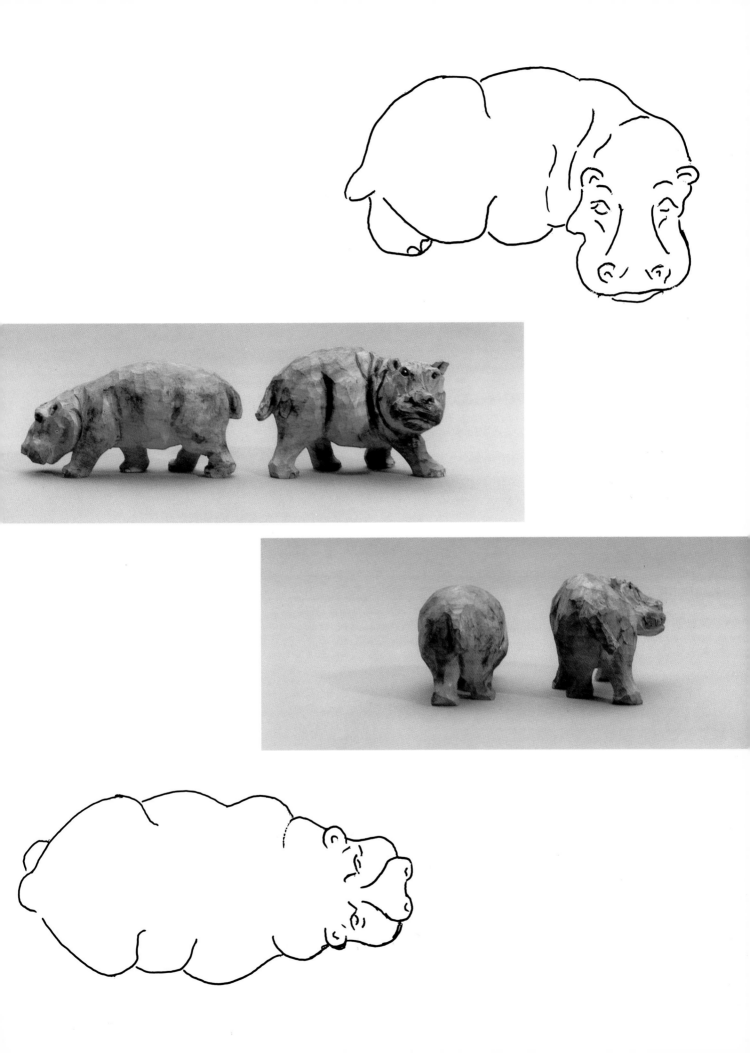

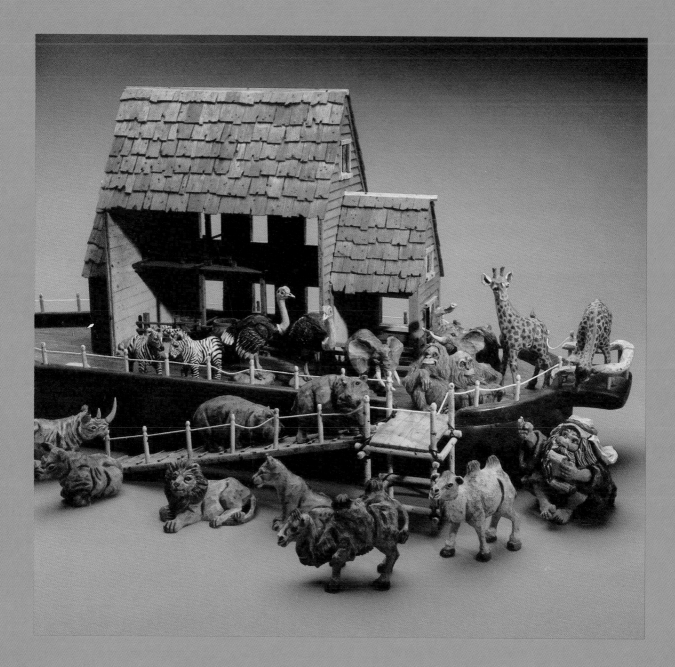

Now that two of every kind is here,
Let's load from the front and step to the rear!